IMAGES
of America

SEABREEZE PARK

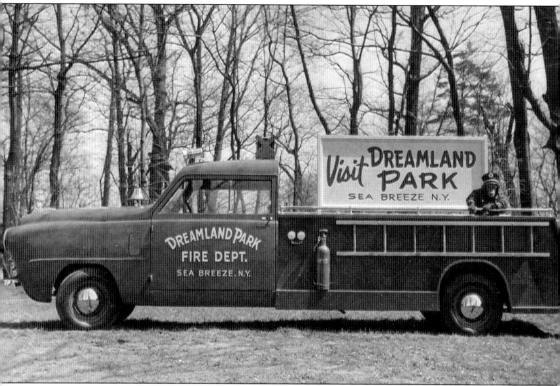

For much of the 1950s, Seabreeze used this fire truck to give rides around the park and to appear at local events. Over the course of its nearly 140-year existence, the park has had three names. It was originally the two-word Sea Breeze. In 1939, George Long renamed it Dreamland, as seen on the fire truck. It became Seabreeze in the 1970s. (Seabreeze Archives.)

ON THE COVER: Riders are getting ready to board the Virginia Reel in this picture from 1925. The Virginia Reel, a cousin of the roller coaster, was built in 1921 and featured a series of round tubs careening around a switchback track. (Seabreeze Archives.)

IMAGES
of America

SEABREEZE PARK

Jim Futrell
Foreword by John Norris

ARCADIA
PUBLISHING

Published by Arcadia Publishing
Charleston, South Carolina

Printed in the United States of America

Library of Congress Control Number: 2018930640

For all general information, please contact Arcadia Publishing:
Telephone 843-853-2070
Fax 843-853-0044
E-mail sales@arcadiapublishing.com
For customer service and orders:
Toll-Free 1-888-313-2665

Visit us on the Internet at www.arcadiapublishing.com

To families—
the one that supports and shares my passion,
the one that has cared for Seabreeze and made it what it is,
and the thousands that have created memories there.

CONTENTS

FOREWORD

It's a great story, one that dates back 142 years and six generations.

The Long-Norris family, which built its first carousel in Philadelphia in 1876, is today known as one of the oldest families in the amusement industry. Our connection to Seabreeze began in 1904, when George Long's father brought him to Rochester to operate a carousel. Long loved Rochester; he settled here, raised a family, and bought the park in the 1940s. He and sons-in-law Bob Norris and Merrick Price operated the park and enjoyed a thriving business in the post–World War II era.

During that time, the fifth generation of our family—Anne, George, Rob and John Norris, and cousin Suzy Price—grew up living on the park property, in houses located at the back of the park. The kids enjoyed the quiet neighborhood in winter, but really loved the excitement of summer, including the sound of the Jack Rabbit going by right next to the house! We started working very young, as is often the case with a family business. Throughout the years, through good times and bad, we had a strong sense of family—loving parents, firm but fair grandparents, and supportive siblings—always there to help each other.

The late 1960s were tough years. Business dwindled, and Grampa George considered selling the park to a condo developer. The kids asked for a chance to run the business themselves; he gave us the opportunity, and we never looked back. Season after season, our desire to improve Seabreeze never ceased. With the help of a dedicated staff, we took a rough-around-the-edges, open-gate local amusement park and grew it into the popular regional summer destination that it is today.

None of this would have been possible without the continued support of our staff and our guests. Many thanks to the thousands of employees who have worked at the park over the years; your efforts to provide a great guest experience helped keep a Rochester institution alive and well. And a special thank-you to the millions of Seabreeze visitors since 1879; your support and your smiles made it all possible.

Our generation is honored to carry on the tradition of providing quality summer fun, and to have the sixth generation—Genevieve, Alex, and Jack Norris—guide Seabreeze into the next century. For us it's been a great ride, and we look forward to the next 100 years!

—John Norris

ACKNOWLEDGMENTS

Telling the story of one of the world's oldest operating amusement parks and the enduring family legacy that has been part of that story for more than a century cannot be the work of one person. Rather, it represents the collective efforts of many, many people.

First and foremost, I would like to thank the family that has overseen Seabreeze for more than 80 years—George Norris, Anne Norris Wells, Rob and Deb Norris, John Norris, and cousin Suzy Price Hofsass. They, along with their children, Genevieve, Alex, and Jack Norris, represent the fifth and sixth generations of one of the longest continuous family traditions in the industry. Their continued stewardship of the park and support for this book have been critical in bringing it to life.

Just as important was the involvement of Jeff Bailey, director of marketing at Seabreeze. Jeff has been one of the project's most critical advocates and has been an indispensable resource in providing information on Seabreeze and granting access to its archives. I was also very grateful to the efforts of Seabreeze's two historians, Matthew Caulfield and Kevin Dorey, for their passion for Seabreeze and its history along with their in-depth research on the park. Their work certainly made my job easier and resulted in a better book.

Four people deserve my special gratitude for making this book a reality: my wife and best friend, Marlowe, and our sons, Jimmy, Christopher, and Matthew. They share and appreciate my passion for amusement parks and understand when I had to spend time working on this book when they might have wanted me to do other things.

The images in this volume appear courtesy of the Seabreeze Archives (SB), including photographs from the Irondequoit Historical Society, the New York Museum of Transportation, and the Rochester Public Library; Tom Rebbie, president and chief executive officer of Philadelphia Toboggan Coasters Inc. (PTC); and Jim Futrell (JF).

INTRODUCTION

For nearly 140 years, Seabreeze Park has been as constant a presence on Lake Ontario as the waves lapping against the shore, marking the march of time. The story of Seabreeze, the fourth oldest operating amusement park in the United States, is the story not just of a business that has endured through good times and bad but also of the family that has been associated with the park for over a century.

Seabreeze represents one of the best remaining examples of the classic amusement park experience—the traditional-style amusement park with its shaded picnic grounds, action-packed midway, family-oriented rides, and nostalgic atmosphere. Today, it is a true survivor: of the hundreds of "trolley parks" that once dotted America, Seabreeze is one of just 11 that remain in operation.

While Seabreeze's history goes back for nearly a century and a half, it represents just part of a rich industry legacy that goes back over 500 years, when pleasure gardens spread throughout European cities between the 1500s and the early 1800s. They provided a place to escape the dreary conditions in teeming cities and featured attractions that are familiar today, including landscaped gardens, live entertainment, fireworks, dancing, and even predecessors to today's merry-go-round, roller coaster, and Ferris wheel rides.

In the late 1700s, America was emerging as a nation of its own, and simplified versions of the European pleasure garden began to appear. Vauxhall Gardens, named after a renowned pleasure garden in London, opened in New York City around 1767 and featured one of America's first carousels. Soon, picnic grounds were springing up outside many American cities.

The industry really came into its own in the decades following the Civil War. With the Industrial Revolution sweeping the nation, people flocked from the countryside into cities, creating conditions like what existed in Europe a few centuries earlier. Those cities were linked by America's burgeoning transportation infrastructure as it spread throughout the country. While it was making the nation smaller, it was also playing a critical role in developing the amusement park industry, as people with increasing amounts of money and free time were seeking ways to be entertained.

The first developers included railroads that sought to build passenger traffic by developing early amusement parks in rural areas and steamship companies that established resorts along waterfronts in the Northeast and the Midwest. But it was the spread of the trolley that established the amusement park as an American icon.

By the time the first electric-powered trolley line opened in Richmond, Virginia, in 1888, Seabreeze had been in operation for nearly a decade, with steam-powered trains and boats providing service from central Rochester. Nationwide, hundreds of trolley lines popped up around the country almost overnight. To maximize revenue, the operators sought a way to attract riders during lightly used evenings and weekends. Opening amusement resorts provided the ideal solution. Typically built at the end of the lines, they were initially simple operations consisting of picnic facilities, dance halls, restaurants, games, and a few rides. But as simple as they were, they tapped a huge unmet demand and spread across America.

As Seabreeze entered the 20th century, it too became a true trolley park, as it was purchased by the local trolley company. Electric streetcars replaced the steam trains, delivering thousands of customers. It was also at this time that its future was forever linked to the family that continues to operate the park today. In 1904, George Long Sr. arrived at Seabreeze with a carousel. At the

time, he was just one of many independent business people who set up concessions at amusement parks around the country. But by then, the Long family had already been involved in the business for nearly 30 years.

George's father, Edward, and uncle Fielding Long emigrated from England in 1858 with their sons Robert Arthur and Uriah and settled in Philadelphia. While the family business was originally weaving wool and velvet, the miniature carousels created by Uriah intrigued the brothers. As a result, in 1876, they became one of America's first carousel manufacturers when they built a horse-driven ride that operated in Philadelphia's Fairmont Park. Over the next 27 years, the family built seven more carousels.

As the Longs completed carousels, Edward's four children each took responsibility for one, providing an entry into the amusement park business. Robert Arthur and his descendants ended up at Eldridge Park in Elmira, New York. Arthur Long and his family eventually took over Bushkill Park in Easton, Pennsylvania. Lois Long followed a family carousel to Blackpool, England, where she married John Outhwaite, an early partner at Blackpool Pleasure Beach.

The fourth sibling, George Long Sr., initially operated the family's fifth carousel at Ontario Beach, an early competitor to Seabreeze, in the mid-1890s. But in 1899, the Longs completed their newest carousel, and George took responsibility for finding a place to operate it. Initially, he operated it at two locations in New Jersey, Cape May and Burlington Island, for two seasons each. In 1903, he decided to introduce his 11-year-old son, George Jr., to the business and took him to Norfolk, Virginia, to operate the carousel at a new amusement park, Pine Island. The park was delayed, and the pair spent the summer living in a shack on the beach.

Fate would intervene the next summer, when the opportunity to bring the ride to Seabreeze arose. Although they initially spent winters in Philadelphia, the bond between Seabreeze and the Longs was never broken.

While George Long Sr. continued to operate the carousel, George Jr., after briefly working elsewhere following college, returned to the park and started taking greater responsibility around Seabreeze. He was able to use his training in engineering to construct new buildings and modernize attractions. In 1921, he helped build his first full-blown ride at Seabreeze, the Virginia Reel.

Like most amusement parks during this era, Seabreeze boomed in the 1920s because of economic prosperity, advances in technology, and customers seeking greater thrills. It was a decade when rides, supplied by a growing base of manufacturers, supplanted more passive attractions as the primary reason people visited amusement parks. Like most of its peers, Seabreeze was completely transformed with new buildings and attractions. But the prosperity of the decade did not last.

The Depression severely impacted the amusement park industry, and hundreds of facilities closed throughout the country. While Seabreeze was able to hold on, it was a difficult decade for the facility, as it was plagued by fires and the financial problems of its owner, New York State Railways. As a result, many concessionaires were closing at Seabreeze. But George Long Jr. continued to believe in the park, investing in his operations, and in 1937, he took over management of the facility.

The hard times of the Depression gave way to the materials shortages and travel restrictions of World War II. But it was a prosperous time for the industrial economy of Rochester, leading to good times for Seabreeze, and in 1946, George Long was able to purchase control of the park.

America emerged from World War II a changed nation. While a strong economy and a population looking to put the war behind it provided a much-needed boost to the industry, returning veterans were focused on pursuing the American Dream and were leaving the urban centers, where most amusement parks were located, and flocking to the suburbs to raise their families. Attractions like kiddielands and theme parks provided additional competition to older parks that were struggling with aging infrastructure, declining neighborhoods, and ownership issues.

Spurred by the opening of Disneyland in 1955, attention in the amusement industry soon shifted to large corporate theme parks that quickly spread throughout the United States. While many older parks were left behind, others managed to change and adapt. Long spent much of the 1950s and early 1960s building numerous new attractions at Seabreeze.

But the late 1960s were a time when many other family-owned amusement parks were closing in the face of rising property values, aging facilities, and the loss of the industrial base that provided much of their critical picnic business. Seabreeze was faced with many of those same issues, and George Long briefly considered selling the park for condominium development.

But unlike so many of his peers in the industry whose amusement parks are now just memories, Long was fortunate in that his five grandchildren were interested in carrying on the family tradition. They took over ownership and modernized and expanded the park.

But even this new generation faced challenges. This included the growing popularity of water-based attractions, an industry-wide shift to corporate-owned facilities that put further pressure on the remaining family-owned parks, and a devastating fire in 1994 that destroyed the beloved antique carousel. But this loss gave a new generation of the family an opportunity to create another Long carousel.

Despite advances in technology, demands of time, and changes in consumer tastes, the ageless appeal of amusement parks remains unchanged. A relaxing summer day with family and friends; pushing the limits on the rides; indulging in foods one would not consider consuming elsewhere; and making memories to last a lifetime all combine to create an experience that cannot be duplicated.

Seabreeze Park remains one of the finest examples of a family-owned and -operated amusement park that through shrewd management and wise investment has been able to thrive in a changing world and industry. And as the waves of Lake Ontario continue to mark the march of time, so too will Seabreeze Park.

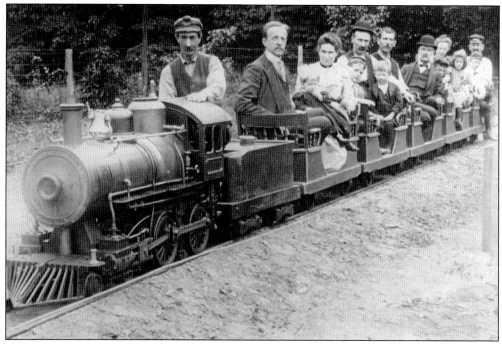

The Long family is pictured on a train ride at Burlington Island, New Jersey, in 1902. George Long Sr., who brought a carousel to Sea Breeze in 1904, launching the family's century-plus affiliation with the park, is seated just behind the engineer. Ten-year-old George Long Jr., who would take over Sea Breeze in 1937, is seated in the front of the second car. (SB.)

One

THE BEGINNINGS
1870s TO 1910s

Even before Sea Breeze opened in 1879, the headlands where Lake Ontario meet Irondequoit Bay had become a popular gathering place for boating, fishing, picnicking, or just enjoying the cooling lake breezes. In 1865, George Allen purchased five acres at Sea Breeze and converted a large house into a three-story hotel called the Allen House. It was soon followed by other hotels, and in 1874, the Lake Shore Railroad started providing service along the shore of Lake Ontario.

Following the Philadelphia Centennial Exposition in 1876, Michael Filon put together an investor group to purchase surplus railroad equipment from the fair with plans to link central Rochester to Sea Breeze. The group acquired 50 acres on the bluff, erected a terminal building, and constructed a six-mile train line. The first train of the Rochester & Lake Ontario Railroad, also known as the "Dummy Line" due to the shape of its locomotives, arrived on August 5, 1879, signaling the opening of Sea Breeze amusement park.

Throughout the 1880s, the park grew. A new pier was added to improve boat access, more hotels were built, a series of merry-go-rounds appeared, and the first roller coaster was erected in 1886. It reportedly only lasted a short time before being washed away by the lake waves.

A train wreck in 1899 sent the railroad into receivership, and the Rochester & Suburban Railway Company purchased the railroad and all its assets, including Sea Breeze, in October 1899. Taking possession on January 1, 1900, the new owner replaced the steam trains with electrified trolley cars and began improving the park. New attractions included a zoo, the Figure 8 roller coaster, and most importantly, a new carousel that was brought to Sea Breeze by the Long family, whose descendants now own the park. As the 1910s ended, Sea Breeze was a well-established business. Its rides were popular attractions, and a young George Long Jr. was taking on an increasingly high profile.

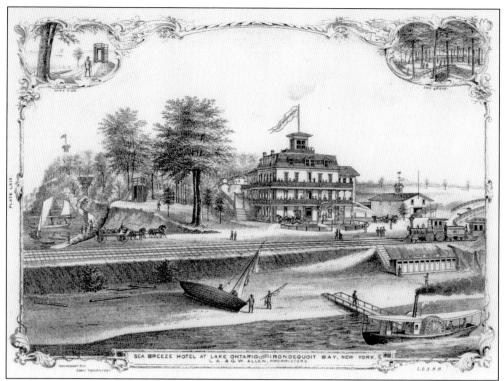

Even before Sea Breeze opened in 1879, the property had become a popular place to enjoy cooling lake breezes on a hot summer day. The first major investment occurred in 1865, when George Allen purchased five acres of land at Sea Breeze and converted a large house into a three-story hotel called the Allen House. It later became the Sea Breeze House but burned down in 1885. (SB.)

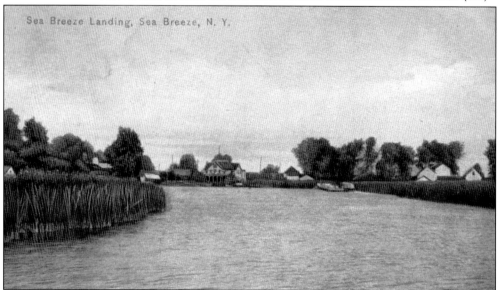

The appeal of Sea Breeze in its early years was its pastoral setting, providing an escape from the crowded conditions of the cities. At the time, the roads did not separate the park from the waterfront. As seen here, the park went right down to Irondequoit Bay, giving visitors a waterfront escape. (JF.)

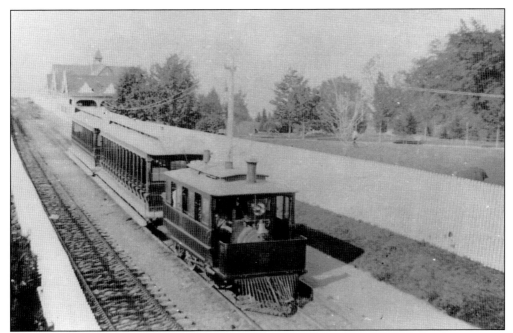

On August 5, 1879, Sea Breeze was born when the Rochester & Lake Ontario Railroad began service from central Rochester. The railroad included two locomotives and eight coaches that ran between the park and downtown. The unique structures over the locomotive's boiler were to prevent the engine scaring off horses. It also gave the railroad its nickname, the Dummy Line. (SB.)

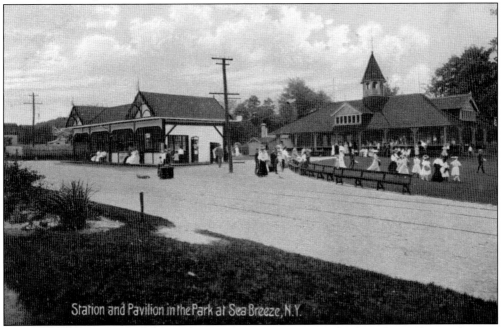

Station and Pavilion in the Park at Sea Breeze, N.Y.

Two of the earliest structures in the park were the train station and pavilion. The pavilion, on the right, served as a central gathering area at the park, offering space for dining and dancing. An updated station, built in 1915, has been incorporated into the main food and games building on the midway, while the pavilion has been converted into the park office. (JF.)

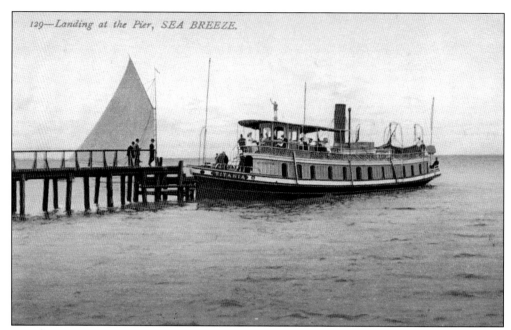

129—Landing at the Pier, SEA BREEZE.

Even before Sea Breeze opened, the area was a popular transportation hub for people traveling to various local resorts. Boat service began from Ontario Beach in Charlotte, to the west, and from downtown Rochester via the Genesee River as early as the late 1860s, and was one of the earliest ways to access the area. In 1880, a pier was constructed to improve boat access to the park. (JF.)

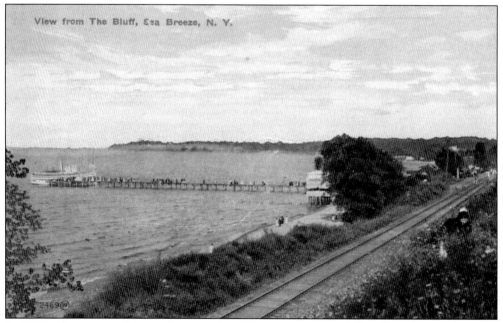

View from The Bluff, Sea Breeze, N. Y.

In 1886, a longer pier (pictured) measuring 475 feet, was erected. Strolling the pier over the waters of Lake Ontario was as much a part of the experience as the boat ride. In the foreground are the tracks of the Lake Shore Railroad, which started service along the shore of Lake Ontario in 1874. (JF.)

14

Picnicking has been a part of Sea Breeze since the beginning. The park's original picnic area was located in a wooded grove in the southeastern portion of the property, accessible by a bridge over a large ravine that crisscrossed the park in its early years. It was a popular location for concessions. Even today, picnicking is a major attraction at the park, with hundreds of groups gathering every season. (JF.)

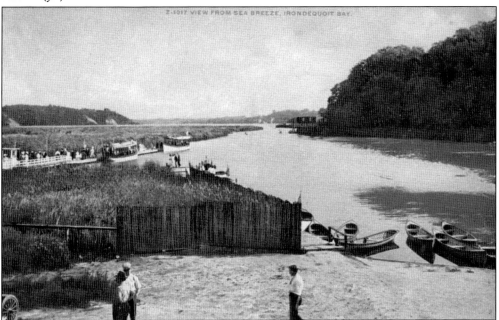

In the years before the construction of the Sea Breeze Expressway in the early 1950s, the park extended to the bay, making it part of the park. Similar to most amusement parks during that era, a popular diversion was boating. Guests could choose between rowboats, canoes (seen in the foreground, a popular choice for young couples), or larger launches (background). (JF.)

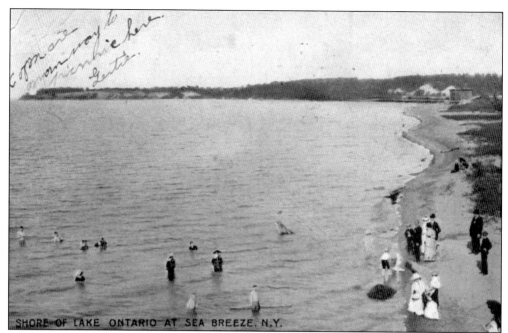

SHORE OF LAKE ONTARIO AT SEA BREEZE, N.Y.

In addition to easy access to Irondequoit Bay, access to Lake Ontario was much easier in Sea Breeze's early years. Even then, the cooling waters of the lake were an attraction, and swimming was a popular diversion, although as seen here, the dress was much more modest than today. (JF.)

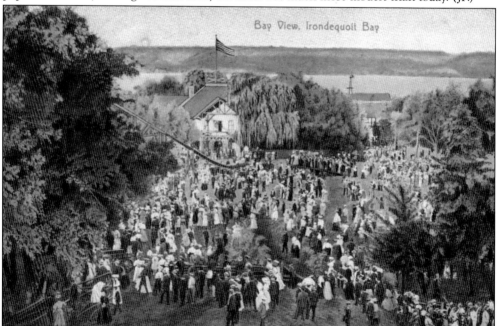

Bay View, Irondequoit Bay

While many made Sea Breeze their summer resort of choice, others preferred to travel among the various lake and bay resorts. Ontario Beach Park and Windsor Beach were popular destinations on Lake Ontario, while Bay View (pictured), Newport, Birds and Worms, and Glen Haven, complete with an amusement park of its own, were popular places on Irondequoit Bay. Each resort had its own features and allure. (JF.)

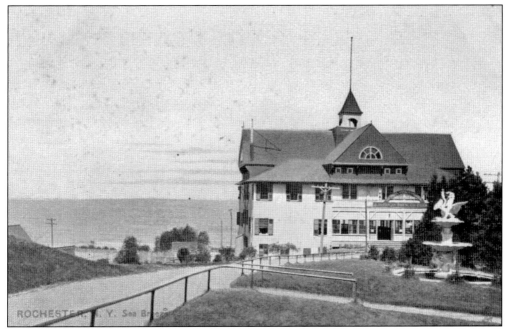

Throughout the park's early years, a series of pavilions served as the social center of the facility. Some focused on dancing, others on dining, and some just provided a place to rest. One of the most notable was this two-story structure, the Pavilion Hotel, which was erected in 1888. Located at the north end of the park overlooking Irondequoit Bay and Lake Ontario, it featured a stage for live entertainment. It remained a prominent attraction at Sea Breeze until it burned down in 1909. In the foreground above is a fountain that was a fixture at the park until the 1960s. (Above, JF; below, SB.)

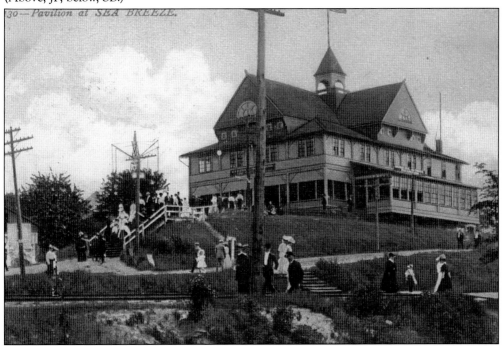

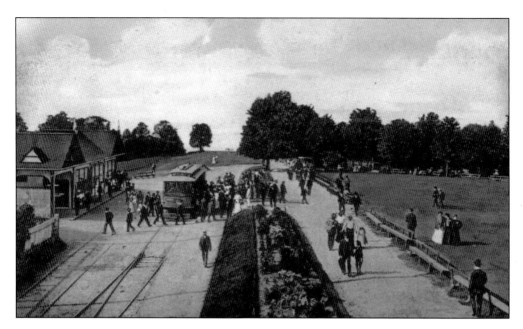

In 1900, following the purchase of the park by the Rochester & Suburban Railway Company, the railroad was converted to an electric trolley line. Up to 14 cars were used to accommodate the crowds, and by 1903, the trolley route was expanded to a double-track line. The train station was converted into a trolley station (above), and riders disembarked onto an expansive lawn that was perfect for strolling (below). Despite the electrified trolley line, electricity throughout the park was limited at that time. Rides were powered by steam. Trolleys continued to serve Sea Breeze until August 30, 1936, when the system was abandoned in favor of buses. Meanwhile, the old steam trains that were so important in the park's early development were retired to a coal mine in Pennsylvania. (Both, JF.)

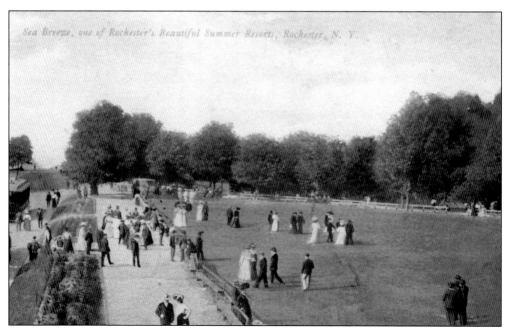

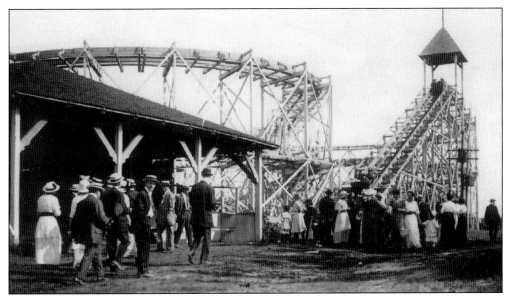

The neighborhood's first roller coaster, Stahley's Roller Coaster, appeared on the shores of Lake Ontario in 1886. It was destroyed by winter storms after a few years. In 1903, it was followed by the Figure 8 (pictured). Built for $20,000 by the Ingersoll Construction Company of Pittsburgh, it was a gentle ride in which four-passenger vehicles traveled along a track resembling a large figure eight. The ride closed in 1915. (SB.)

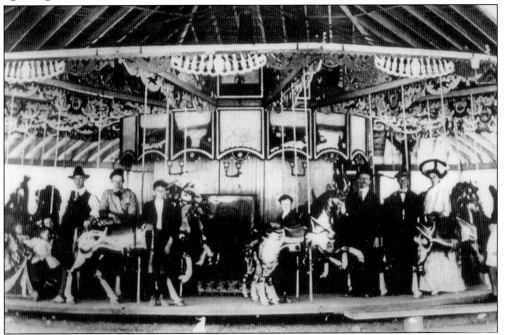

The first known carousel to operate at Sea Breeze debuted in 1883. Over the next two decades, numerous other carousels made appearances at the park, brought in by outside concessionaires. In 1904, one of those concessionaires, George Long Sr., arrived with a carousel his family had built five years earlier. The boy in the center of the photograph is George Long Jr., who would later come to own the park. (SB.)

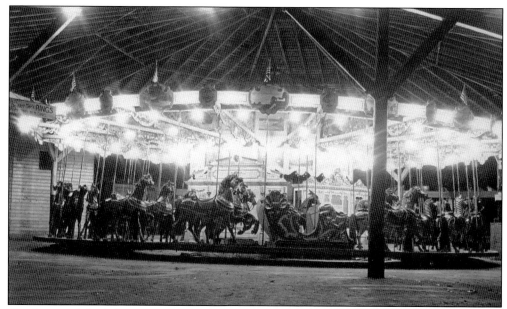

The Longs relished the opportunities at Sea Breeze, launching a relationship that continues to this day. They continued to maintain and update their carousel, initially operating it in a building at the current site of the Jack Rabbit's loading platform. It was swapped in 1926 with the carousel at nearby Seneca Park, where it operated until being destroyed by a fire in 1942. Seneca Park's carousel, PTC No. 36, was moved to Sea Breeze. (SB.)

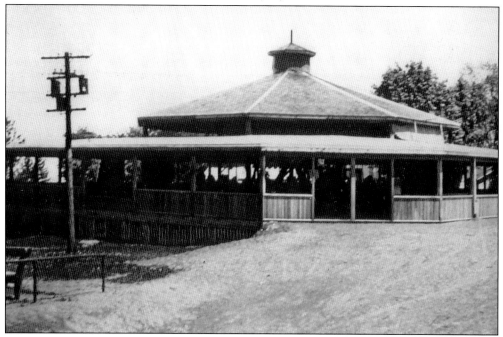

In 1915, the Longs were approached about leasing their carousel building for use as a dance hall. As a result, they moved their ride to a new location where this structure was constructed. It was the first major construction project for George Long Jr. and would serve as the home of the park's carousel until being destroyed by fire in 1994. (SB.)

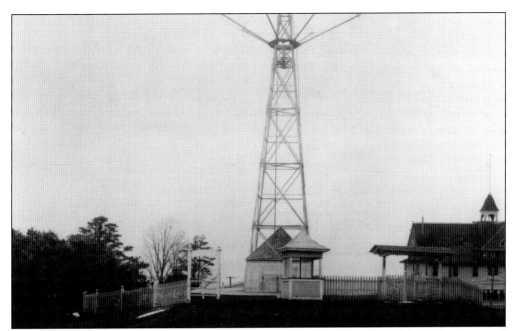

Sea Breeze featured a series of circle swing rides beginning in 1906. One of the earliest types of amusement rides, it consisted of vehicles circling a large tower. The original, which used wicker gondolas, was replaced by a new version in 1921 using airplane-shaped vehicles that operated until 1934. (SB.)

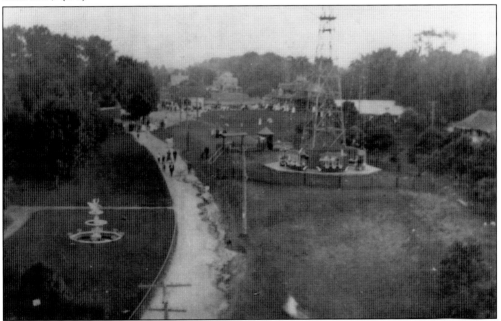

This view to the south from the Pavilion Hotel around 1910 provides a good overview of the north end of the park. Among the notable features are the fountain and the circle swing with its wicker gondolas. The walking path leads to the trolley station, while the pavilion that currently serves as the park office is to the right. Beyond the trees on the left would be the Figure 8 and carousel. (SB.)

For most of its early history, Sea Breeze operated in the shadow of Ontario Beach Park. Also located on the shore of Lake Ontario, five miles west of Sea Breeze, it was promoted as the "Coney Island of western New York." Like Sea Breeze, it started with the development of hotels in the 1870s, but by 1884, it was a full-blown amusement resort. While Sea Breeze had more of a rural feeling, Ontario Beach featured a boardwalk packed with elaborate buildings and attractions, including the Fighting the Flames show, the Trip to the Moon, a Japanese garden, and the Scenic Railway. In 1919, the park closed after a series of fires, and the land was converted into a public park, although its carousel remains. Sea Breeze entered the 1920s as the leading amusement park in Rochester. (Both, JF.)

NIGHT SCENE FROM LAKE ONTARIO, ONTARIO BEACH PARK, ROCHESTER, N.Y.

Two

Highs and Lows
1920s and 1930s

As Sea Breeze entered the 1920s, like the amusement park industry as a whole, it was entering its first golden age. It was a time when rides were becoming the most important features at amusement parks, and Sea Breeze was no different.

Manager Bertram Wilson sought to transform the park into a nationally recognized amusement center. In 1920, the park kicked off a major expansion, adding the Jack Rabbit (its most enduring attraction), the Old Mill, a fun house, and the Dreamland dance hall. The Virginia Reel, Aeroplane Swing, and a bumper car ride followed in 1921. Much of this was destroyed by a fire in 1923, but Sea Breeze rebounded, and expansion continued with the Natatorium, Wild Cat roller coaster, and its legendary PTC No. 36 carousel debuting.

But the good times did not last. Another major fire hit the park in 1930, signaling the turbulent decade to come. With the Depression descending on the country, consumer spending dried up, and business at the amusement park dropped dramatically. In the face of declining revenue, other challenges piled up, threatening the park's very existence.

Fires continued to plague Sea Breeze, costing it major attractions like the Jack and Jill (formerly the Virginia Reel), and the Greyhound roller coaster. The Wild Cat was removed, the Natatorium shuttered, steamboat service to the park was halted, concessionaires were closing, and in 1936, the trolley company abandoned its lines to the park.

Despite this bleak outlook, George Long Jr., who continued to increase his involvement, saw opportunity at the facility. In 1937, he rented the park from the trolley company and added several new attractions, including the Lightning Bug, Caterpillar, Dodgem, Alligator Farm, and the Jungle, a display of live monkeys. In 1939, he changed the name of the park to Dreamland.

As the 1930s ended, the park had made it through arguably its most challenging decade, unlike so many of its peers. It entered the 1940s with a new sense of optimism under the enthusiastic stewardship of George Long Jr.

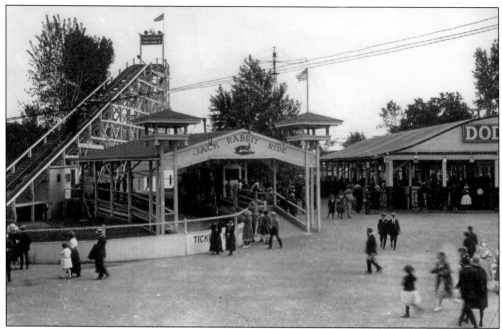

By the 1920s, rides were taking on an increasingly high profile in amusement parks around the world. Sea Breeze was no different, and in 1920, the park added several new attractions. The Jack Rabbit roller coaster was designed by the Dayton Fun House Company and built by Miller & Baker. John Miller is considered the father of the modern roller coaster, inventing safety features that are still common, like the anti-rollback, which gives roller coasters that distinctive click-click, and the underfriction system of locking the train to the track. The Jack Rabbit was one of the first roller coasters to take advantage of this new technology. Riders were treated to a hilly, 2,130-foot-long layout that included a 75-foot drop, going below ground level, and a helix. (Both, SB.)

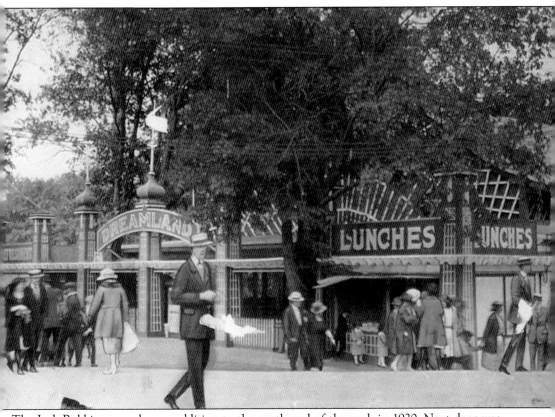

The Jack Rabbit was only one addition to the south end of the park in 1920. Next door was the Old Mill, also built by Miller and Baker. It featured a quarter-mile-long, water-filled trough through which boats traveled that wound underneath the Jack Rabbit. Next to the Old Mill was the Dreamland dance hall, the largest open-air dance hall in western New York. Built over the ravine that ran through the park, Dreamland offered a concession stand in addition to dancing. A fun house–style attraction was built under Dreamland in which patrons would slide through darkness from the midway down to the bottom of the ravine and then follow a labyrinth back up underneath Dreamland. The fun house was remodeled in 1921 and became known as Hilarity Hall. (SB.)

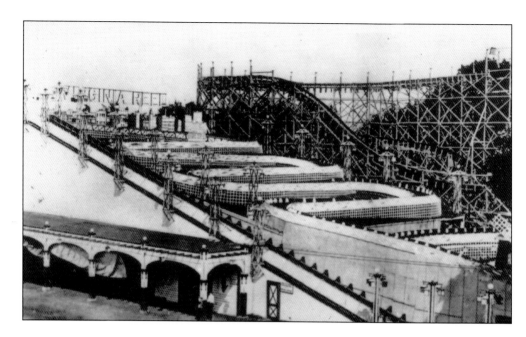

Hilarity Hall was one of four new attractions added in 1921. The largest was the Virginia Reel, a unique roller coaster–type ride that featured large tubs that traveled down a series of switchbacks with a helix at the end. Sea Breeze's model was built adjacent to the Leap-the-Dips roller coaster, which opened in 1916. The $45,000 ride was laid out by Henry Riehl of Coney Island, who was credited as the ride's inventor, naming it after his daughter Virginia. Construction was overseen by Arnold Neble and Charles Walker, who were joined by George Long Jr. Over the next few decades, Long built several additional rides. (Both, SB.)

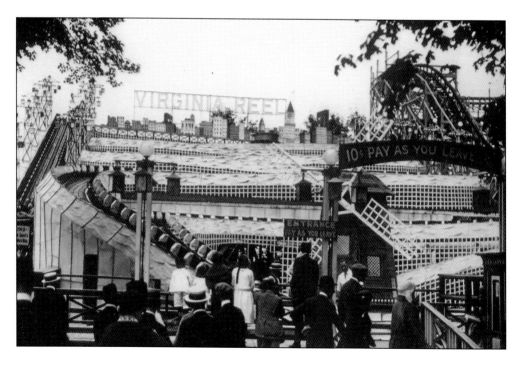

Also in 1921, Arnold Neble contracted with the Dodgem Corporation of Salisbury Beach, Massachusetts, to install a Dodgem bumper car ride in the building seen here in the background. It was converted into the Giggles dark ride in 1929. Next to the Dodgem was the Aeroplane Swing, installed by Hons Amusement Company. To the right, next to the Jack Rabbit, is the tunnel for the Old Mill. (SB.)

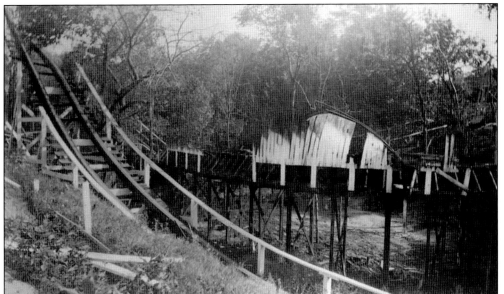

On August 27, 1923, a fire broke out in the Old Mill just after midnight that destroyed much of what had been built in the previous few seasons. By the time the flames were extinguished, the Dreamland dance hall, which opened in 1920, and the two-year-old Hilarity Hall fun house were gone. The Old Mill suffered major damage, and the Jack Rabbit lost its station and lift hill. Damage totaled $150,000. (SB.)

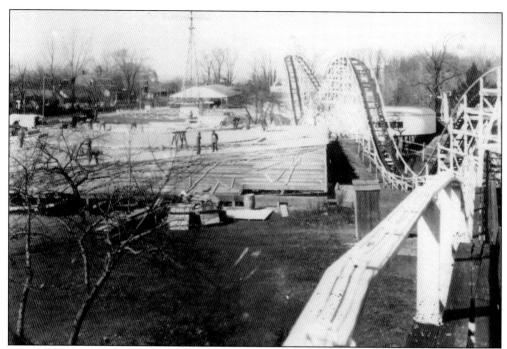

The park worked quickly to repair the damage from the fire. The Jack Rabbit and Old Mill were rebuilt, while a new dance hall, Danceland, was constructed on a new parcel south of the Aeroplane Swing using plans from the destroyed Dreamland. The above picture shows construction well underway, with repairs complete on the Jack Rabbit and Old Mill, and work on Danceland's floor to the left. The new dance hall was constructed using laminated wooden trusses, ensuring a column-free dance floor (below). (Both, SB.)

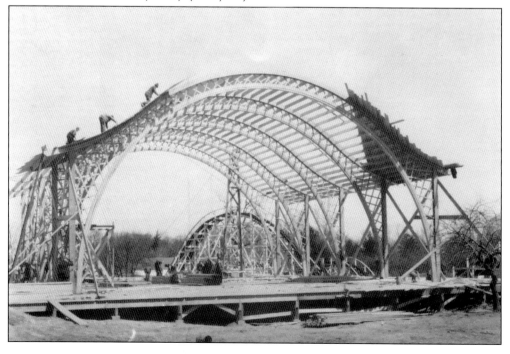

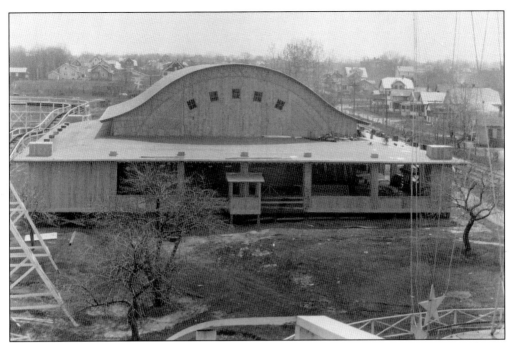

This photograph, taken from the top of the Jack Rabbit, shows construction nearing completion on Danceland. The structure was very similar to other dance halls built during the era, with an arched roof and open sides to let in the summer breezes. (SB.)

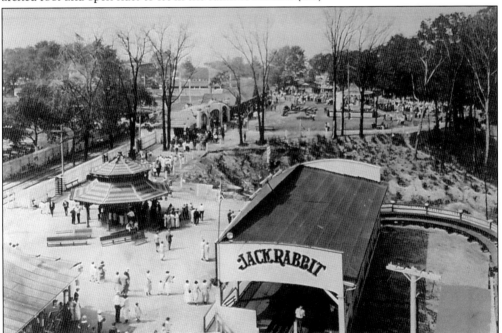

A look at the park from the Jack Rabbit following the completion of repairs shows some of the differences. Before the fire, Dreamland and the Old Mill entrance were behind the Jack Rabbit. Both were subsequently rebuilt farther south, opening up the central area of the park. The ravine over which Dreamland was located before the fire can be seen at center. (SB.)

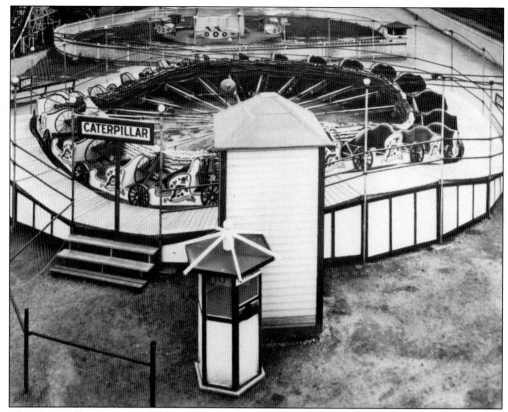

The Caterpillar made its debut in 1924, installed between the Dodgem and the Aeroplane Swing. The Caterpillar was created in 1923 by the Traver Engineering Company of Beaver Falls, Pennsylvania. It featured a train traveling over an undulating circular track at high speed. A canopy covered the train during the ride, providing young couples a chance to steal a kiss. (SB.)

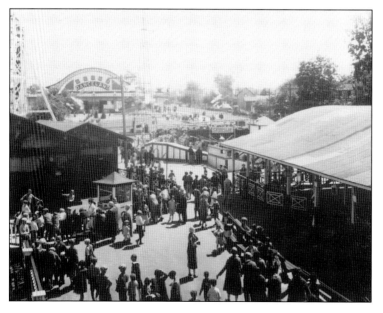

This view of the south end of the park shows the impact of the expansion in the 1920s and the increasing importance of rides at Sea Breeze. The Jack Rabbit is on the far left, with the Old Mill station underneath it. The building on the right is the Dodgem. The Caterpillar, Aeroplane Swings, and Danceland are all behind it. (SB.)

In the spring of 1924, construction started on the Natatorium, developed by the Natatorium Construction Company Inc., which proposed a national chain of swimming complexes. Built at a cost of $400,000, it was billed as the largest inland saltwater pool in the world and the only inland one when it opened on July 1, 1925. Covering three acres south of Danceland, the Natatorium featured a 300-by-125-foot pool, a stage for entertainment, a sunbathing promenade, bleachers for observers, a toboggan slide, a water merry-go-round, and 6,500 lockers. Its one million gallons of water were pumped in from Irondequoit Bay and filtered, salt was added, and the water was heated to a constant temperature of 72 degrees. Initially, all-day admission cost $3, but this was eventually lowered to 25¢. High operating costs and the pressures of the Depression led to its closing in 1935. (Above, SB; below, JF.)

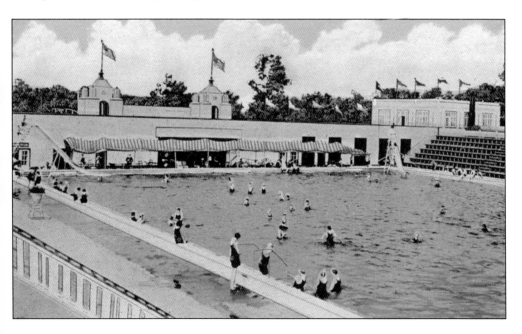

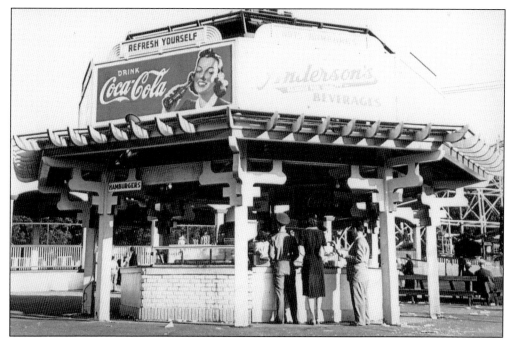

Refreshments have been an important part of the amusement park experience since its beginning, and Sea Breeze is no different. This refreshment stand, the Pagoda, debuted next to the Jack Rabbit in 1920 as part of the expansion that year. It was a fixture on the midway for the next 50 years and was known for its hamburgers, Richardson's Liberty Root Beer, and Anderson's Beverages. (SB.)

By the mid-1920s, the world was a changing place. The automobile was gaining popularity as a preferred transportation method. This meant that ridership on trolleys and boats was declining, and Sea Breeze had to adapt by adding parking facilities. This image shows a parking lot off Culver Road, an area that is still used for parking nearly a century later. (SB.)

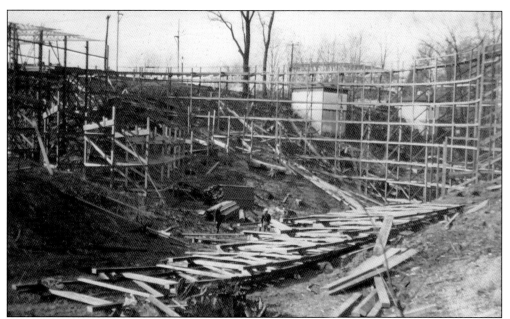

In 1926, another roller coaster joined the lineup at Sea Breeze, the Wild Cat. It was built roughly where the Dreamland dance hall was located and crossed the park's ravine. This image shows several vertical supports, or bents, at the bottom of the ravine waiting to be lifted into place. The Leap-the-Dips, by then renamed the Greyhound, can be seen in the background. (PTC.)

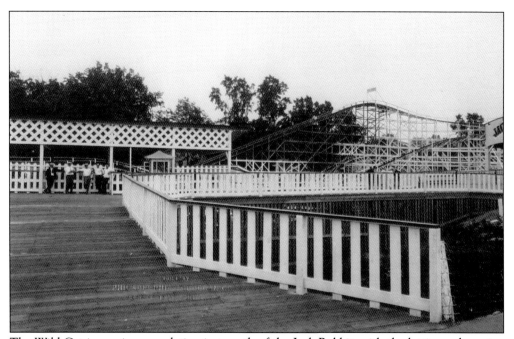

The Wild Cat is nearing completion just north of the Jack Rabbit, with the latticework station on the left. To provide access to the Wild Cat and the south end of the park, a large boardwalk had to be built. (PTC.)

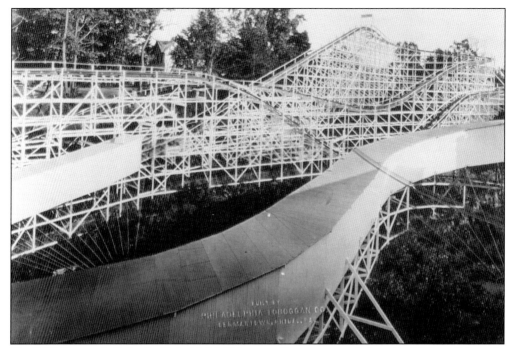

The Wild Cat was built by the Philadelphia Toboggan Company and designed by Herbert Schmeck. It stood 93 feet tall with 2,800 feet of track. As seen above from the loading station, the ride started with a left-hand drop into a long tunnel leading to the lift hill. Unlike the deep dips on the Jack Rabbit, the Wild Cat featured more gentle hills. The image below shows the back turn of the ride behind the lengthy brake run, built high over the ravine. The open-front trains are headed back into the station. (Above, PTC; below, SB.)

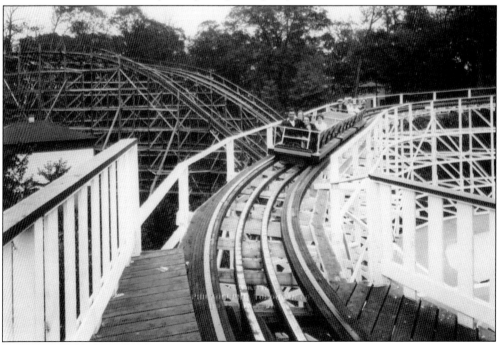

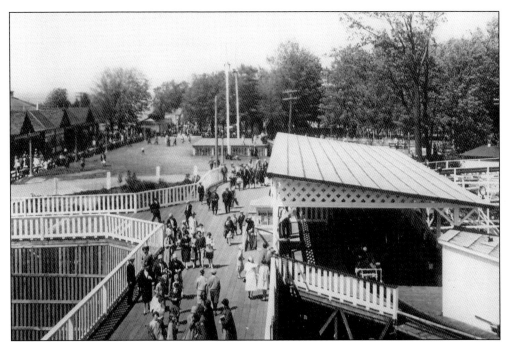

A view from the top of the Jack Rabbit station toward the north, shortly after the completion of the Wild Cat, shows a train getting ready to depart. It also provides a great view of the towering boardwalk constructed over the ravine. The trolley station can be seen on the left. (SB.)

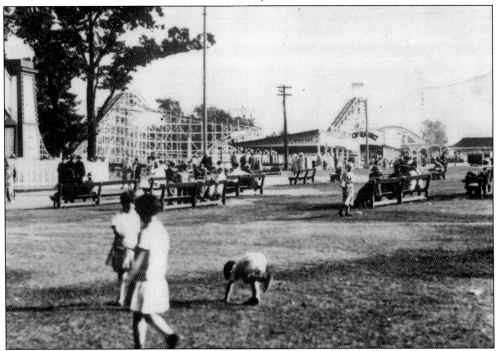

This view from the trolley station in the late 1920s shows how the Wild Cat filled a gap between the Jack Rabbit and the park's central lawn and stage. By this time, Sea Breeze was at its early peak, with three roller coasters, the Virginia Reel, and at least 10 other rides. (SB.)

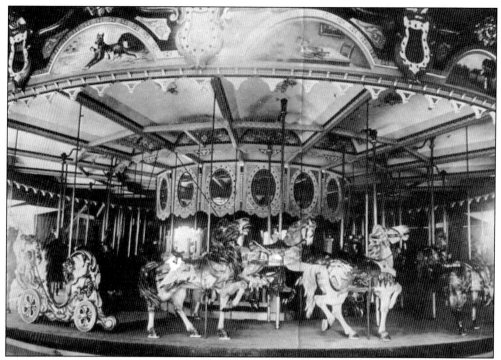

In 1915, the Long family purchased a brand-new carousel from the Philadelphia Toboggan Company. Known as PTC No. 36, the ride was 48 feet in diameter and featured 48 hand-carved horses. The ride originally operated at Seneca Park, a municipal park in Rochester, but in 1926, the Longs decided that the newer ride was a better fit at Sea Breeze, and it was swapped with the Long machine that had been at Sea Breeze since 1904. The Longs used a Ford Model T truck to haul the carousels to their new homes. In 1931, Sea Breeze purchased a new Wurlitzer Model 165 band organ, shown below in the 1980s. The new ride quickly became the soul of the park and on busy days would attract as many as 5,000 riders at a nickel a ride. (Both, JF.)

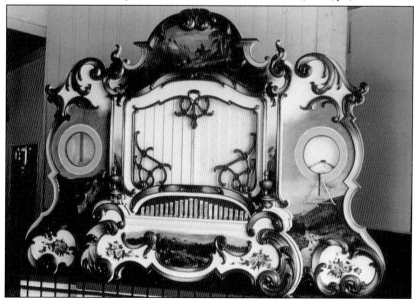

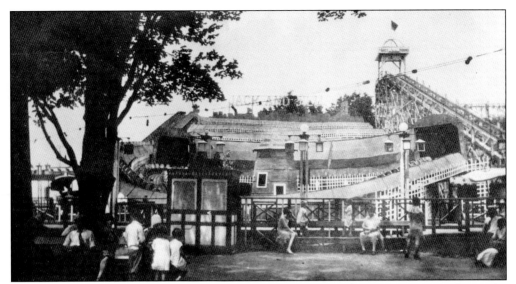

The Virginia Reel underwent a major transformation in 1928 when it was converted into the Jack and Jill. It is not known what exact changes were made, as its basic appearance remained unchanged, although it was promoted as a new attraction, and reportedly the ride experience was toned down. (SB.)

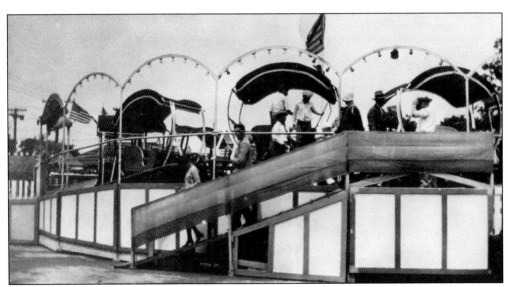

In 1929, the Lindy Loop debuted at Sea Breeze. The ride was manufactured by Spillman Engineering of North Tonawanda, New York, one of the largest early manufacturers of amusement park rides. The Lindy Loop consisted of two-person benches mounted on two runners. The benches would roll freely along those runners as the ride traveled around a track, producing a rocking motion. (SB.)

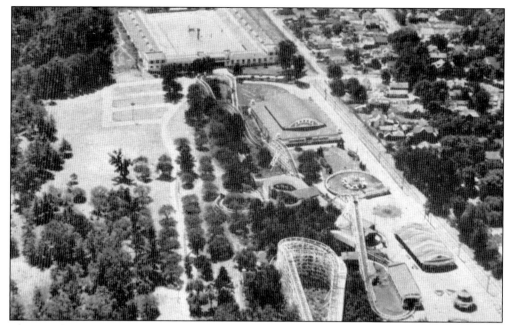

This aerial view from the late 1920s shows how the south end of the park changed during the decade. The Wild Cat's first turn is at the bottom center, with the Jack Rabbit immediately to the right. The Old Mill's tunnel winds underneath. Lined up to the right are the Pagoda refreshment stand, Dodgem, Aeroplane Swings, Danceland, and Natatorium. Up near the Natatorium is a large parking lot. (SB.)

Miniature golf first came to Sea Breeze in 1930, replacing the Tumble Bug. Known as Tom Thumb Golf, each of its 18 holes was between 26 and 50 feet from the tee, and featured sand traps and narrow water hazards. Tom Thumb Golf was closed by the end of the 1930s, but miniature golf was revived in the north end of the park in the 1940s, as seen here. (SB.)

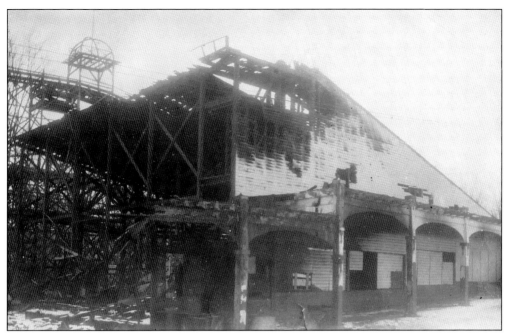

On October 5, 1930, a fire started in a Skee-Ball stand and quickly spread through a series of one-story concession buildings, including two shooting galleries, before reaching the Jack and Jill. By the time the fire was extinguished, the Jack and Jill was destroyed, along with a Dodgem and Cave of the Winds, a walk-through attraction. The Greyhound roller coaster, seen in the background, was also damaged. (SB.)

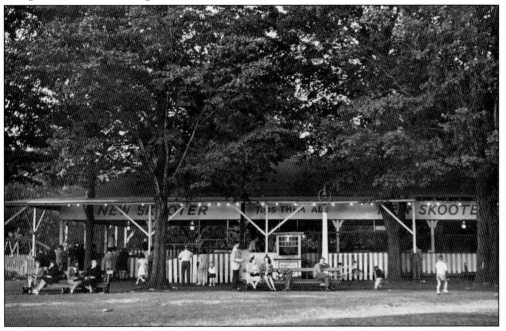

The damage on the Greyhound was repaired, but it was hit by another fire in 1933, at which time it was demolished. The park retained the Greyhound's loading station, and George Long Jr. turned it into a bumper car ride, a role it continues to play to this day. (SB.)

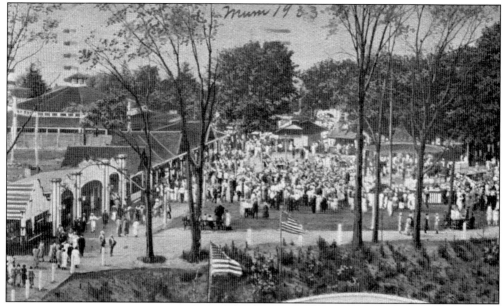

By the mid-1930s, Sea Breeze was feeling the effects of the Great Depression. Money was in tight supply, and business was declining. To attract crowds, Sea Breeze brought in a variety of animal attractions and held free performances on the lawn in the center of the park on a regular basis, as seen in this postcard from 1933. (JF.)

The pressures of the Depression prompted many attractions, such as the Natatorium, to close and other longtime traditions to end. Steamboat service to Sea Breeze had been a fixture on Lake Ontario for nearly seven decades, even before the amusement park existed. But declining ridership and rising costs prompted the end of service during the 1930s. (SB.)

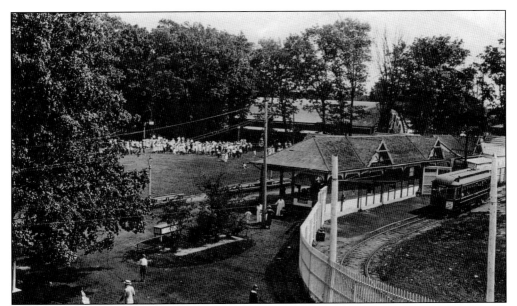

Another once-critical means of access to Sea Breeze were the rail lines, originally steam trains and later trolleys. But by the mid-1930s, Rochester & Suburban's successor New York State Railways, which owned the park, was struggling financially and could not justify serving Sea Breeze. On August 30, 1936, the final trolley left Sea Breeze. Patrons would now have to rely on buses or cars to get to the park. (SB.)

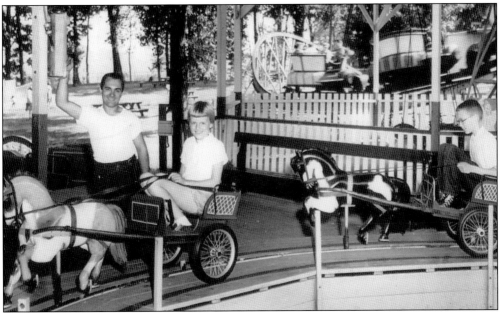

When George Long Jr. took over operation of the park in 1937, he immediately started making improvements. According to *Billboard* magazine, his crew built 12 powerboats, new cars for the train, and six kiddie rides, including the Pony Cart, seen here in the mid-1950s. The horses were carved by the park staff. (SB.)

Another popular ride added in the late 1930s was the Lightning Bug. On the former location of the Virginia Reel, the Lightning Bug was a favorite for approximately 30 years. The Lightning Bug was an updated version of the Tumble Bug ride that operated at the park from 1926 to 1929. The ride, once a staple at amusement parks around the country, consisted of four circular tubs that traveled around a 100-foot-diameter undulating track. The Lightning Bug was manufactured by the R.E. Chambers Company of Beaver Falls, Pennsylvania. Chambers purchased the assets of Traver Engineering Company in 1932. Traver invented the Tumble Bug in 1926. (Both, SB.)

Three

A RENEWED PARK
1940s to 1960s

As the 1940s dawned, what was now called Dreamland was truly George Long's park. The decade started with yet another fire in 1940, this time destroying the Danceland building. The declining popularity of dancing had meant that it had been used as a bingo hall. But Long was undaunted, and converted a portion of the shuttered Natatorium into a new bingo hall.

Soon, America was drawn into World War II. It was a mixed blessing for Dreamland, as the industrial economy of Rochester was thriving with wartime production, but material shortages meant that Long was limited in what he could do with the park. As the war was ending in 1945, Long approached the transit company about buying the park. The asking price was $100,000, to which Long responded "If I had that hundred thousand, I wouldn't even bother with you. I wouldn't even talk with you." Soon the asking price was reduced to $85,000. His business success meant he was able to get a bank loan for $50,000 just on his signature and good name. He paid off the loan in two seasons.

The sale was finalized in 1946, and by 1947, Long was adding several new attractions to the park, many of which were designed and built by him. During this time, Long's daughters, Lois and Betty, and their respective husbands, Merrick Price and Bob Norris, joined him in operating the park. Through the 1950s, many new attractions were added in response to the growing children's business as a result of the postwar baby boom. These included the Junior Coaster, Fairyland zoo, and numerous kiddie rides. Larger attractions like Over the Falls also debuted.

The 1960s were a difficult decade for Seabreeze as it struggled in the face of urban unrest and changing consumer tastes. But Long did what he could to hold on and continued to make improvements, although few new attractions were added. By the end of the decade, it appeared that time might be catching up with Dreamland.

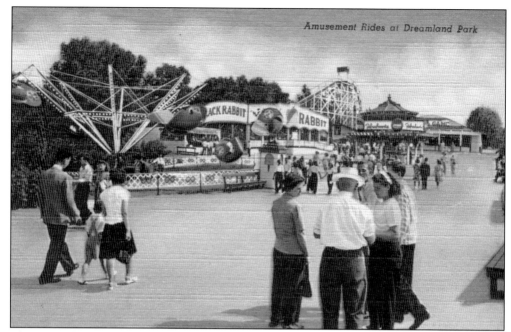

This image from the early 1940s shows the south end of what was now known as Dreamland. In the background, the old Dodgem building has been converted into a games concession. Behind that, Danceland, which had been turned into a bingo hall, was destroyed by a fire on May 1, 1940. By August 1940, however, a new bingo hall was in operation in a portion of the abandoned Natatorium. (JF.)

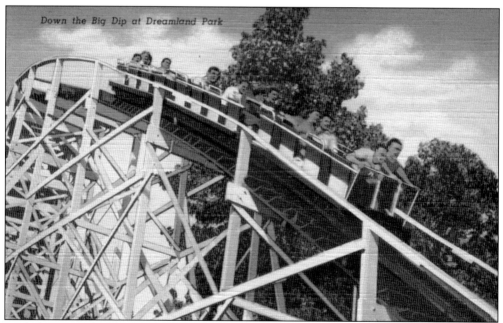

Down the Big Dip at Dreamland Park

With the removal of the Wild Cat following the 1935 season, the Jack Rabbit was the only roller coaster left in the park. But even though it was in its third decade, its popularity was undiminished, as riders lined up to enjoy the hilly ride. The open-front cars were replaced in 1946. (JF.)

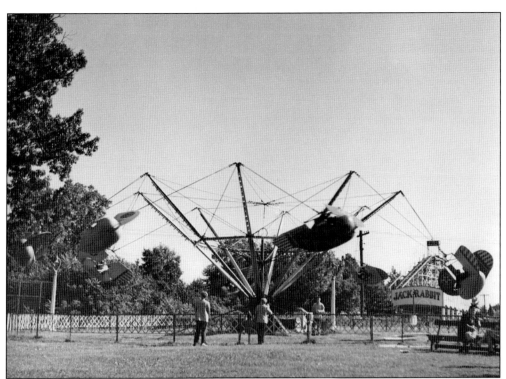

Around 1940, the Flying Scooters was added next to the Jack Rabbit. Built by the Bisch Rocco Company of Chicago, the ride was originally introduced at the New York World's Fair of 1939. The unique attraction permits riders to control their two-person vehicles with a large sail at the front of the car. Now called the Seabreeze Flyers, the ride remains a popular attraction at the park. (SB.)

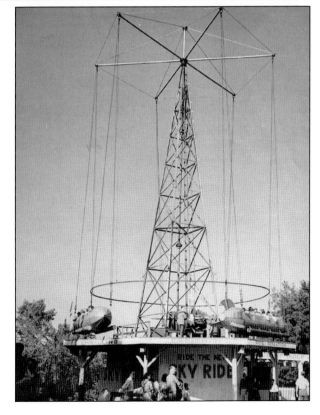

In 1942, Dreamland opened the Sky Ride at the north end of the park, overlooking Lake Ontario. Though it was like the circle swing rides that operated at the park from 1906 to 1934, the Sky Ride featured stainless steel rocket ships instead of airplanes. (SB.)

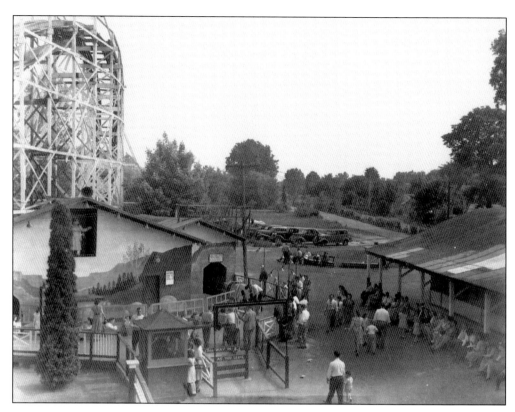

Around 1941, Dreamland decided to create a new attraction out of one of its existing rides. For years, the water-based Old Mill had been plagued by leaks. The park decided to create an all-new dark ride, the Subway, by draining the trough and hauling riders through on a train at a surprisingly high speed. (Both, SB.)

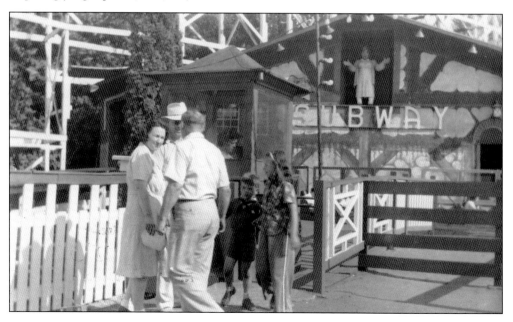

Converting the formerly water-filled troughs of the Old Mill into a dry dark ride demonstrated the ingenuity of the park operators. So too did the development of the ride vehicles on the unique attraction. The park took the cars from the long-gone Greyhound roller coaster and pulled them with a converted Ford Model A. (SB.)

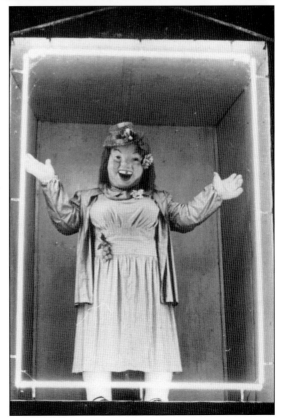

Giggling Gertie stood above the entrance to the Subway, and her cackles wafted over the midway. Gertie was actually a Laffing Sal figure produced by the Philadelphia Toboggan Company of Germantown, Pennsylvania. The figure stood approximately six feet tall, and when activated, it waved its arms and leaned forward and backward. A record player concealed in its pedestal provided the laugh. (SB.)

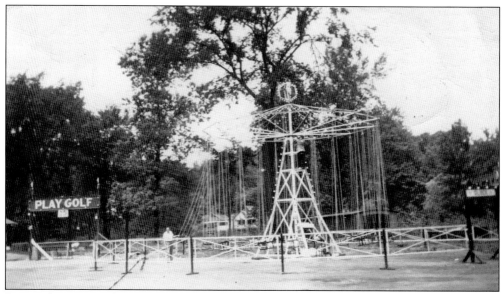

During the 1940s and 1950s, several rides, in many cases set up by independent concessionaires, made brief appearances and were largely forgotten. One of these was the Chair Plane, shown in this 1946 photograph. A simple swing ride, it was built by the Smith & Smith Company of Springville, New York. (SB.)

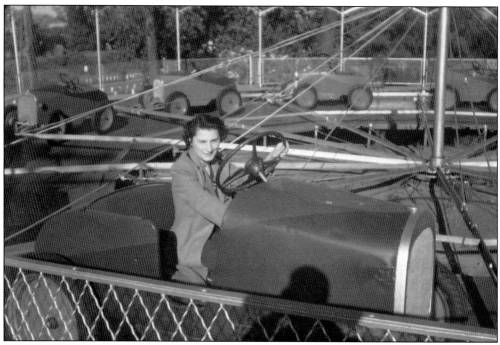

Another attraction at Dreamland during this era was the unique automobile ride seen here in 1948. Called the Leaping Lena, it was essentially a larger version of a kiddie car ride featuring a dozen cars traveling around a central hub. (SB.)

48

Several rides can be seen in this image of the north end of the park from the 1940s. The Sky Ride with its stainless steel rocket ships dominates. Just to the left is the Loop-O-Plane, built by Eyerly Aircraft of Salem, Oregon, which was added in the late 1930s. The Hey Dey, built by Spillman Engineering, is between the Sky Ride and Loop-O-Plane. (SB.)

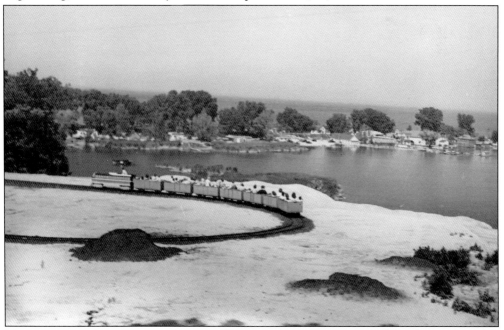

Miniature trains are an important part of a visit to any amusement park, and several models have been a part of the park since the 1920s. This miniature train was manufactured by National Amusement Devices of Dayton, Ohio, in 1947. Until the 1950s, the miniature train treated riders to a lengthy ride past the stage through the picnic grove out to Irondequoit Bay. (JF.)

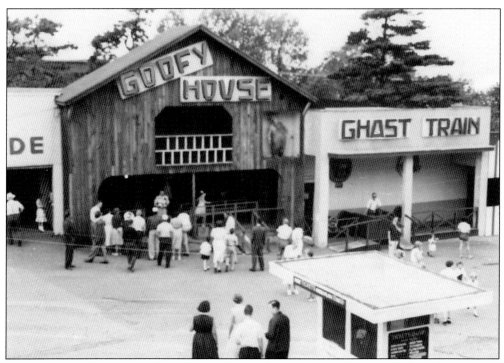

In 1949, the Goofy House made its debut. The Goofy House was a classic walk-through attraction with guests winding their way through darkened passages in the two-story building while negotiating a series of obstacles. The Goofy House was constructed next to the Ghost Train, a dark ride that debuted in 1939 and was built by the Pretzel Amusement Ride Company of New Jersey. The company invented the rail-guided dark ride in 1928 and built over 1,400 during its existence. The name "Pretzel" was selected due to the twisting track in the company's rides. The cars were characterized by a large pretzel on the side of each one. As part of the Goofy House project, a new building was constructed for the Ghost Train. (Both, SB.)

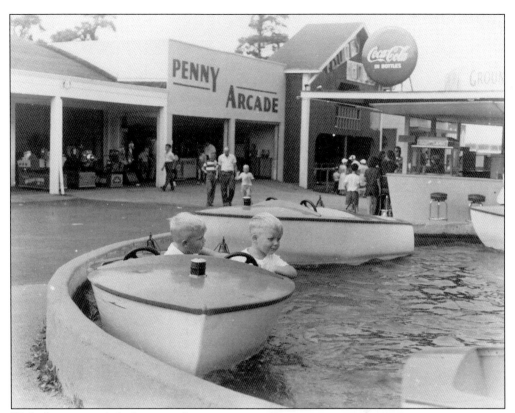

With the postwar baby boom underway, Dreamland started adding more kiddie rides to appeal to growing crowds of children. One of the first additions was the boat ride, which made its debut in 1949 in the north end of the park. It was one of several rides manufactured by the Allan Herschell Company of North Tonawanda, New York, that the park would own. (SB.)

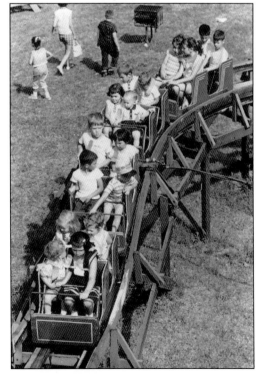

Joining the kiddie boats in 1949 was this small roller coaster. The ride was laid out in a simple oval and was propelled over the gentle dips by an electric motor in the middle of the train. The cable providing power to the motor can be seen on the right. It is not known who manufactured the ride. (SB.)

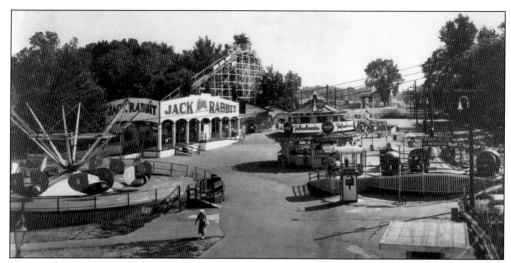

A quiet day on the south midway in the early 1950s shows a view very similar to the one today, with the Jack Rabbit and Flying Scooters being fixtures. The Tilt-A-Whirl, built by Sellner Manufacturing of Faribault, Minnesota, made its debut in 1948, and a newer version of the ride maintains a presence today in a nearby location. (SB.)

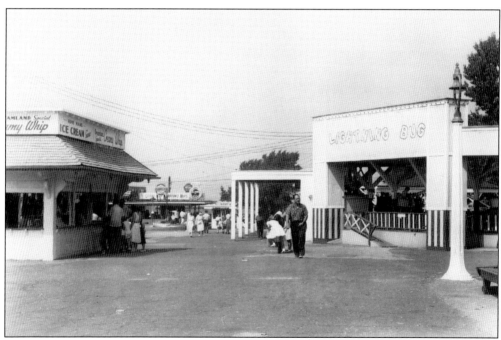

Meanwhile, the north end of the park had undergone dramatic changes since the early 1950s. All of the structures shown here were replaced in the ensuing decades, including the Lightning Bug ride and, in the background, the Lunchbox restaurant. Known for home-style cooking, the Lunchbox was first run by Eleanore Speth and later by the park's paprika-loving chef Emery Fried. (SB.)

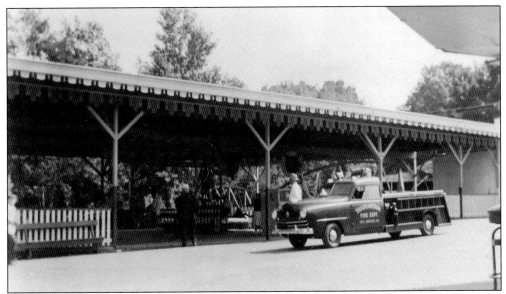

In 1950, Dreamland added the Fire Truck ride. A mocked-up Crosley truck, the Dreamland Fire Department truck not only gave children rides around the grounds but also acted as a rolling billboard for the park, appearing at parades and events around the city. (SB.)

The park has a long tradition of offering free acts to attract guests that continues to this day. It proved important during the hard times of the Depression and during World War II when material shortages limited expansion. This stage, built in 1947 and used through the 1950s, was in a large meadow between the north and south ends of the park at the current location of the Log Flume. (JF.)

The Beautiful View of the Bay
From the Miniature Railroad

In 1952, the State of New York took 16 acres of park property to extend the Sea Breeze Expressway to Lake Ontario, cutting the park off from Irondequoit Bay. The lost property included the picnic groves, an apple orchard, and half of the park's warehouse, which had been built over the former Natatorium after it was used as a bingo hall. Probably one of the most dramatic changes was to the train ride, which had to be rerouted. The expressway can be seen below. (Both, SB.)

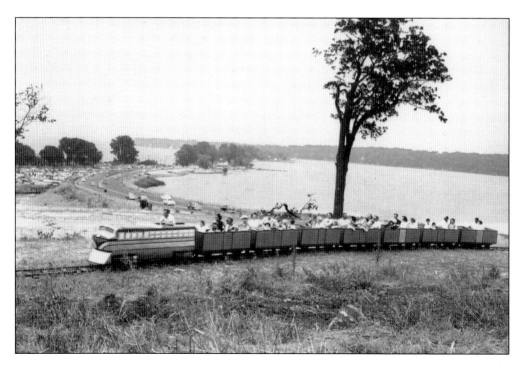

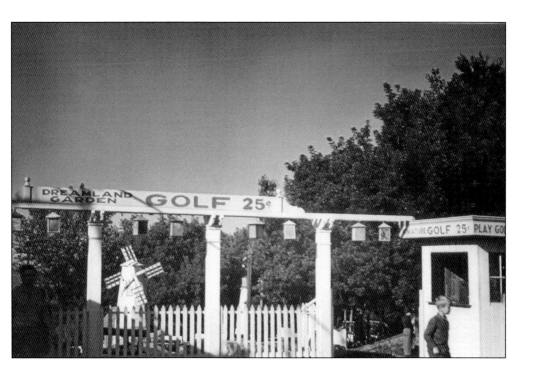

In 1953, in addition to adding more parking, Dreamland responded to the postwar surge in the popularity of miniature golf by modernizing its course, Dreamland Garden Golf, located at the far north end of the park. Along with traditional obstacles like a windmill, the course featured flower gardens and was adorned with lanterns salvaged from the long-gone Virginia Reel and Dodgem. While the miniature golf course was removed in the 1980s to make room for more parking, the lanterns survive today at the train depot. (Both, SB.)

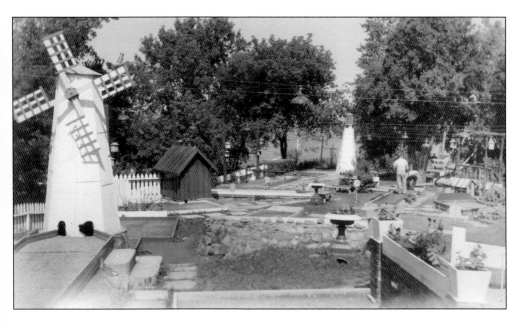

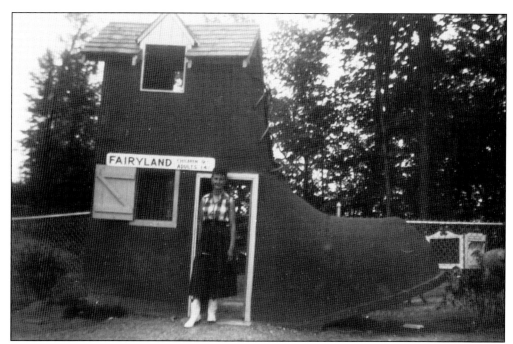

Another new attraction targeting the park's youngest visitors that also made its debut in 1953 was the Fairyland petting zoo. Fairyland was behind the bumper cars, where the picnic groves are located today. Guests entered Fairyland through the Old Woman's Shoe, one of several storybook-themed attractions decorating the zoo. Another favorite was the mouth of a giant concrete whale that kids could walk into and view the fish pond. But the animals were the main attraction and included ducks, sheep, Henrietta the tapir, and Spitzy the llama, a local favorite who is seen below. Fairyland closed in 1964. (Both, SB.)

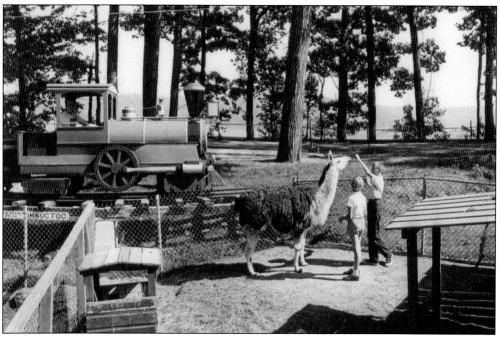

One of the most enduring structures at the park has been the midway building. Originally constructed in the early years of the park as the train station, it was converted into the main games and concessions building once trolley service ended in 1936. The building's appearance remains basically unchanged today from this 1955 view, and its covered walkway makes a great place for shade or to get out of inclement weather. (SB.)

Midway games are a central part of the amusement park experience and have been a part of a visit for more than a century. In addition to the midway building, various games concessions have been found throughout the park since its beginning. (SB.)

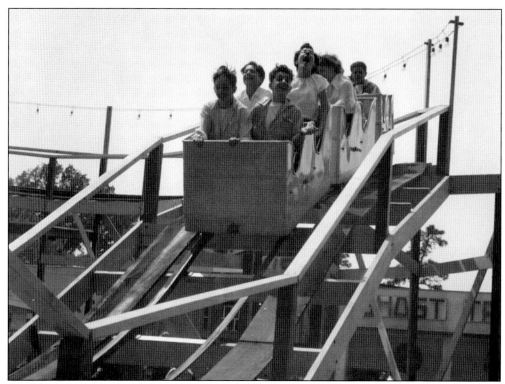

In 1954, a new roller coaster came to Dreamland. The Junior Coaster was a smaller ride built to appeal to the park's growing customer base of children who might have found the Jack Rabbit a little too thrilling. The Junior Coaster was constructed at the north end of the park between the Lightning Bug and the miniature golf course. George Long designed and built the ride, which featured a figure eight–shaped layout. (Both, SB.)

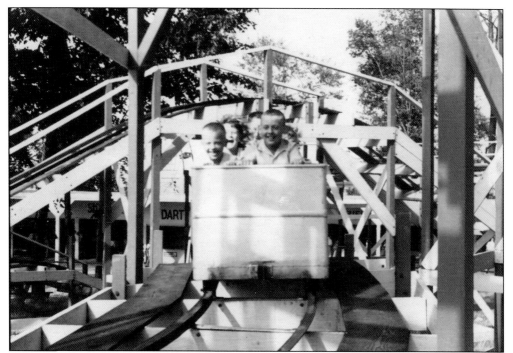

Unlike most roller coasters being built at the time, which were either completely wood like the Jack Rabbit or completely steel, the Junior Coaster featured a unique hybrid design in which steel angle-iron tracks were placed on a wooden support structure. This image provides a good view of the track system. (SB.)

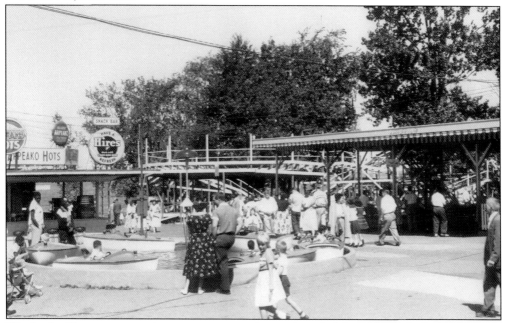

The Junior Coaster was a welcome presence on the north end of the park. With the kiddie boats nearby and a handful of other kiddie rides in the pavilion to the right, it provided Dreamland's youngest visitors with their own amusement park within a park. (SB.)

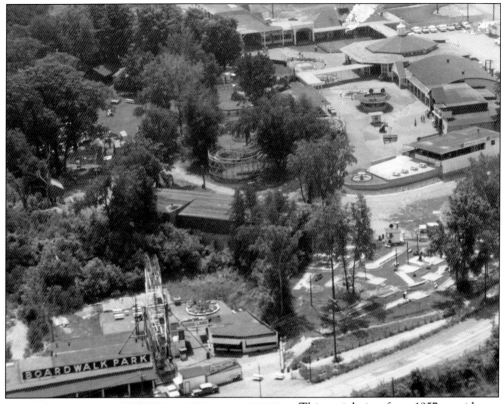

This aerial view from 1957 provides a great overview of the changes made in the early part of the decade. In the bottom right corner is the miniature golf course, while the Junior Coaster is at center. Fairyland is immediately to the left. Boardwalk Park, known for its Ferris wheel overlooking Lake Ontario, is next to the golf course. It closed after the 1962 season. (SB.)

For many years, visitors could reach for the brass ring on the carousel. A ring dispenser would give riders the opportunity to grab steel rings as they rode past. Lucky riders would get a brass ring that they could exchange for a free ride. The tradition harkened back to the early years of carousels, when they were created as training devices for knights. (SB.)

While the park emphasized kiddie and family attractions in the 1950s, it did add a few thrill rides. This ride, known at the park as the Dutch Shoes, went by the generic name Loop-O-Plane. Manufactured by the Eyerly Aircraft Company, the Dutch Shoes flipped riders completely upside down. It operated in numerous locations in the park before being removed in 1976. (SB.)

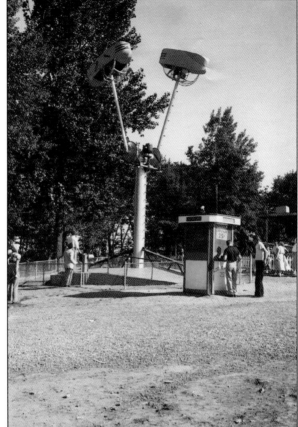

Eyerly Aircraft also provided another new ride to Dreamland in the 1950s in the form of the Rock-O-Plane. The Rock-O-Plane was a cousin of the Ferris wheel in which riders in a two-person cage could control the rocking motion with a brake mounted in each cage, making it possible to flip completely upside down. (SB.)

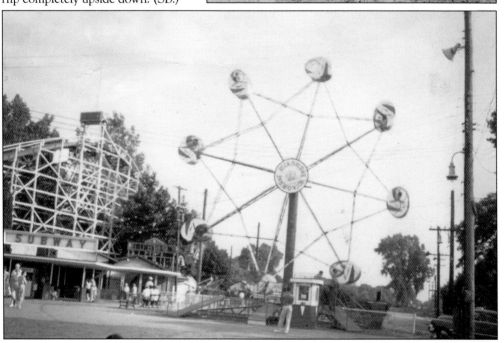

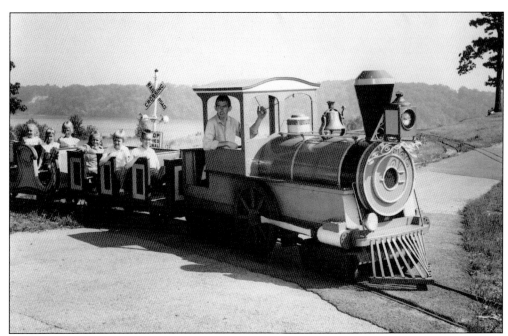

In 1956, the old Sleepy Hollow railroad was replaced by the current train ride. The new train was constructed by George Long and has a one-of-a-kind locomotive and cars. The train cars were converted from mine cars that operated at the Odenbach Shipyard, a nearby shipyard that built utility vessels for the US military during World War II. Like its predecessor, the new train ride has had numerous routes over the years, originally traveling out to Irondequoit Bay, as seen above. Today, while the train remains the same, it travels on a much shorter 1,200-foot-long route around the park's lagoon. (Both, SB.)

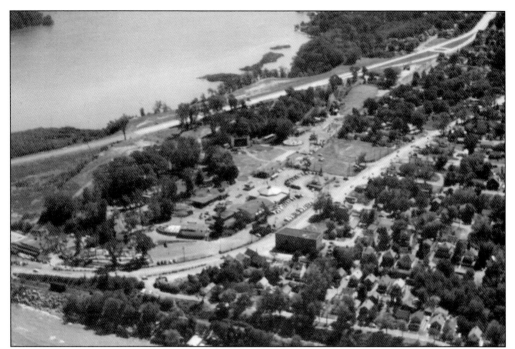

This aerial view shows Dreamland in the 1950s. By then, the park was separated from Irondequoit Bay by the Sea Breeze Expressway. While the Jack Rabbit and Flying Scooters anchored the south end of the park (top), most of the activity remained clustered around the main midway that surrounded the carousel building (center). (SB.)

With the postwar baby boom in full effect in the 1950s, the park made it a point to cater to its youngest visitors by installing a series of kiddie rides. The Sky Fighter was added in 1955. Manufactured by the Allan Herschell Company, the ride, now known as the Star Rockets, remains a favorite among the park's younger visitors, as here in 2004. (JF.)

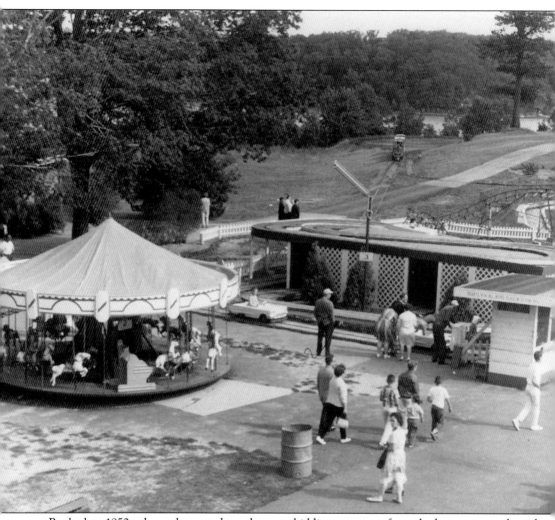

By the late 1950s, the park created another new kiddie area across from the bumper car ride with three rides. It remains the hub of the park's kiddie rides to this day. The kiddie merry-go-round on the left was a scaled-down version of a full-sized carousel that was also manufactured by the Allan Herschell Company. Next to that was the T-Birds, a kiddie turnpike ride that was installed in 1958 and remains in operation today. Behind the T-Birds was a new kiddie roller coaster built by the B.A. Schiff Company of Miami, Florida. It was a peppy little ride that was the perfect introduction to the joys of a roller coaster. The kiddie coaster only operated for a few seasons. In the background is the train ride, which at the time ran to the back of the park property. It is approximately where the waterpark is now located. In the background, the waters of Irondequoit Bay can be seen behind the trees. (SB.)

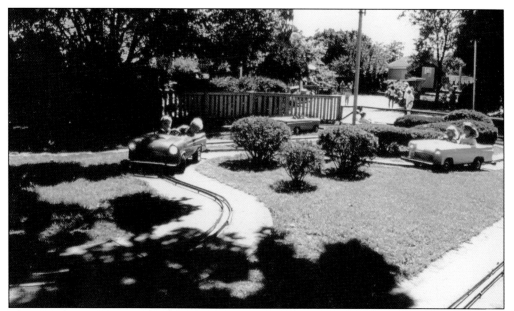

The T-Birds remain a popular feature in the park's Kiddie City, the current kiddieland, as seen in this view from 2004. The ride was another product of the Pretzel Amusement Company, and its timeless appeal among small children has meant it has outlasted numerous other kiddie attractions despite several revisions in its layout. (JF.)

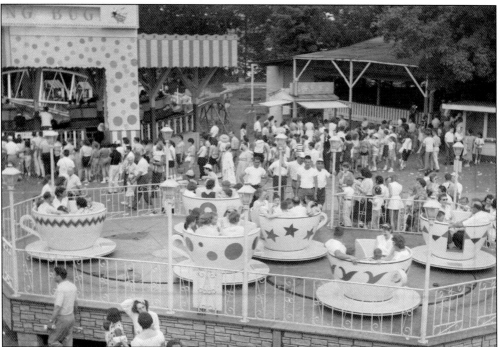

Dreamland added several rides in 1958, including the Crazy Cups. Manufactured by the Philadelphia Toboggan Company, the ride featured six vehicles shaped like giant tea cups that traveled between two circular disks resulting in a figure eight–shaped path. Riders were able to spin their own vehicle independently. The Crazy Cups was a fixture on the north end until 2010. (SB.)

65

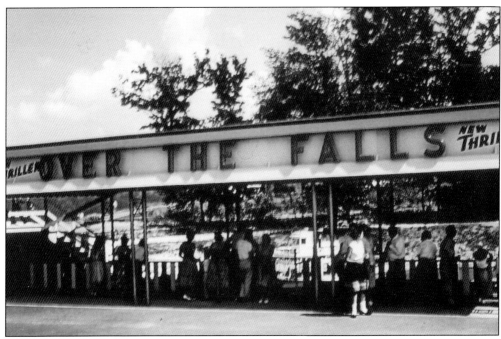

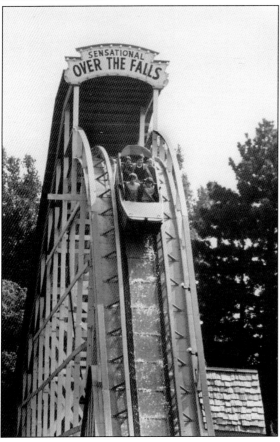

Capping off the 1958 expansion was one of the park's most popular attractions, Over the Falls. Over the Falls was a shoot-the-chutes ride that featured boats traveling through a trough and over a hill, where they would splash down. The park purchased plans for the ride from Euclid Beach Park in Cleveland, and during construction, George Long sensed that something was not right about the dimensions for the boats. He built them a few inches narrower than the plans specified. While Seabreeze's boats made it through the channel without problems, Euclid Beach's got stuck and had to be reworked. (Above, JF; left, SB.)

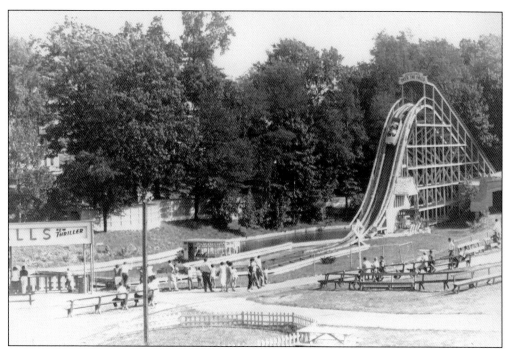

A forerunner of today's Log Flume ride, Over the Falls was developed in the middle of the park between the Jack Rabbit and the kiddieland, where the stage had existed for decades. A lagoon was created to hold water for the ride, forever changing the landscape in that part of the park. (SB.)

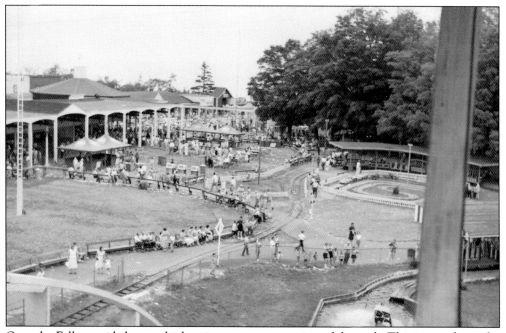

Over the Falls provided a new high point to get an overview of the park. This image shows the recently installed T-Birds next to the train station before the track was reconfigured into its current alignment. The north end of the park can be seen in the distance. (SB.)

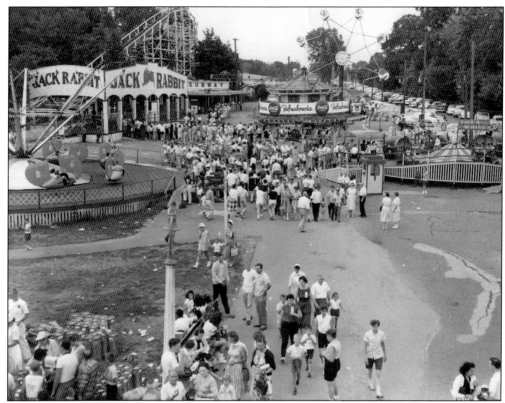

Seen here is a busy day in the late 1950s on the park's south end. In addition to longtime staples such as the Flying Scooters, Jack Rabbit, and the Subway, the Rock-O-Plane, behind the Pagoda, was a new feature on the midway. During this time, there was no fence around the park, and guests could walk directly in from the parking lot. (SB.)

The north end during this period was anchored by the carousel on the left, which was connected to the Lightning Bug by a covered walkway. On the back left are the Penny Arcade, the longtime home to a variety of games, the Goofy House, and the Ghost Train. The Junior Coaster is located beyond the Lightning Bug. (SB.)

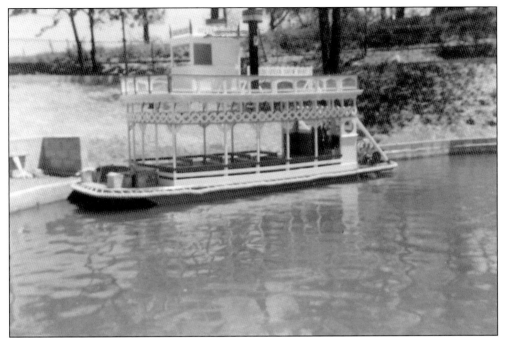

Dreamland kicked off the 1960s by adding the Delta Queen paddleboat ride. A scaled down replica of a paddlewheel riverboat, it was designed and built by George Long. The boat would ply the waters of the Over the Falls lagoon, but it was soon realized that the lagoon was too small to provide a good ride. The declining popularity of the ride prompted the park to remove it in 1965. But the boat did not go away—it was moved to a location near the Arcade and converted into the Carlos' Tacos stand. It later became a soft drink stand in one of the picnic groves. (Both, SB.)

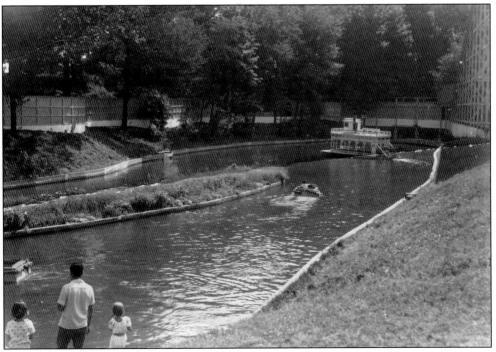

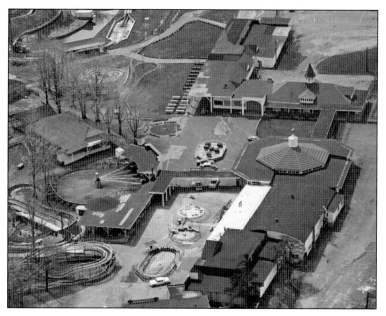

This aerial view of the park from 1961 shows how much Dreamland changed in the 1950s. Over the Falls and the T-Birds are at the top, with the Crazy Cups between the Lightning Bug and Carousel. The Junior Coaster is at the bottom, with the kiddie coaster in front of it. The new go-kart track can be seen between the Junior Coaster and Lightning Bug. (SB.)

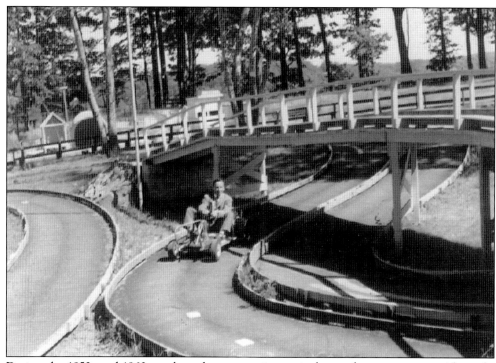

During the 1950s and 1960s, go-karts became an increasingly popular amusement, with tracks popping up around the country. In 1961, the park installed its own go-kart track on its north end. It was a lengthy, twisting track that crossed over itself several times. (SB.)

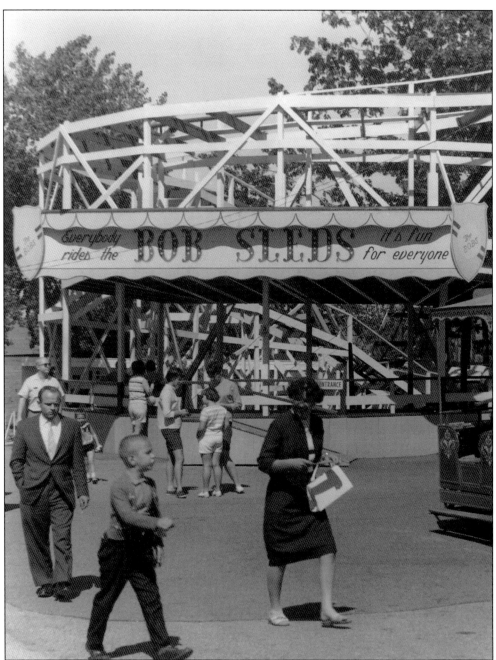

Around 1960, George Long traveled to Disneyland to check out its newly installed Matterhorn Bobsleds roller coaster. He was intrigued with the ride's pioneering use of track made out of tubular steel and the flexibility it offered in designing rides. He sketched out some ideas on Disneyland Hotel stationery and brought them back to the park. Given resource limitations, he decided that the best approach would be to convert the Junior Coaster into a new ride, resulting in the development of the Bobsleds, still one of the most popular rides at the park. It is pictured here not long after it opened. (SB.)

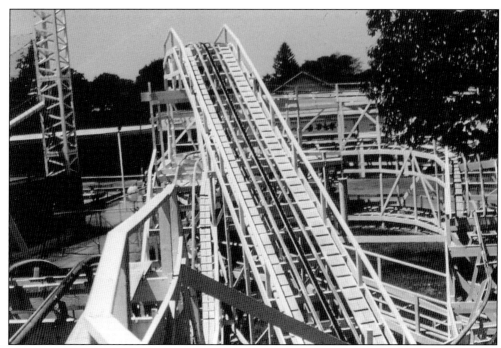

To convert the Junior Coaster into the Bobsleds, Long removed the steel angle-iron track and hand-bent tubular steel for the new track. In addition, he increased the height of the support structure and added an extra layer of track. The boxy two-car, four-person trains were replaced by sleek fiberglass two-seat cars that travel individually around the track. The completed ride stands 31 feet tall with a 28-foot maximum drop and a top speed of 23 miles per hour along 1,240 feet of track. It represented just the second application of tubular steel track on a roller coaster, now an industry standard. (Both, JF.)

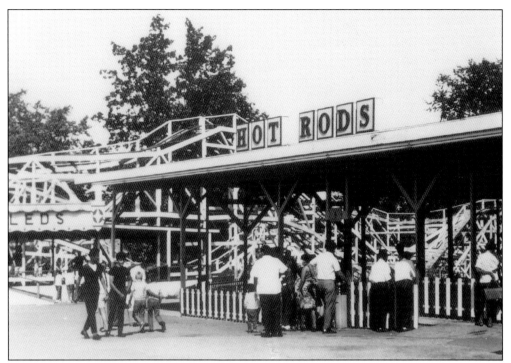

In 1965, Dreamland decided to replace the go-kart track with the Hot Rods ride. The Hot Rods, imported from Europe, were essentially an upgraded version of the go-karts they replaced. The Hot Roads lasted much longer than the go-karts, operating until the late 1970s. (SB.)

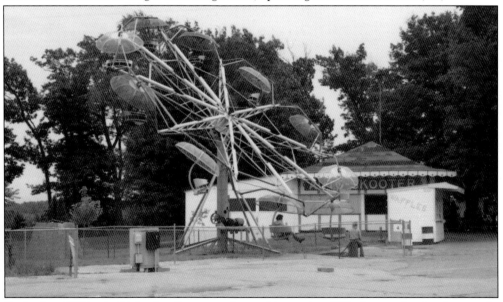

By the late 1960s, the Lightning Bug was aging and becoming difficult to maintain. As a result, the ride was removed and replaced by the Paratrooper. Built by Frank Hrubetz and Company of Salem, Oregon, it was a flashy addition to the changing midway. Dreamland's version only loaded one car at a time, unlike later versions that lower to the ground to permit all cars to load at once. (SB.)

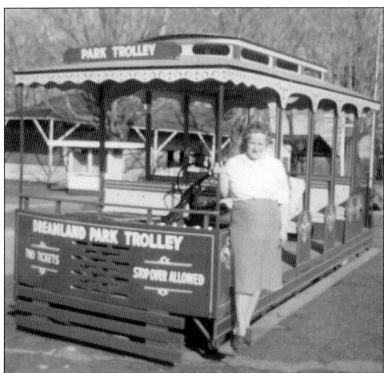

Dreamland paid tribute to its history in the 1960s by building a new-generation trolley ride. Unlike its predecessors, the new trolley did not operate on a track but was a modified truck on rubber tires. The trolley traveled around the park grounds shuttling guests among the attractions. (SB.)

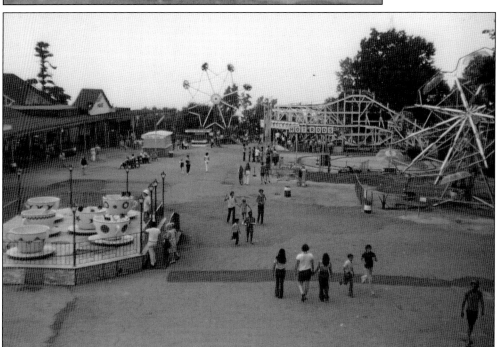

This late 1960s photograph of the north end of the park shows Dreamland's newest attractions: the Paratrooper, Hot Rods, and Bobsleds lined up on the right. In the back is the Rock-O-Plane, which was relocated from the south end of the park. It would remain in that location until 1988. (SB.)

74

Four

A New Generation
1970s to 1985

By the early 1970s, it looked like Dreamland might join the ranks of so many other family-owned amusement parks and fade into the history books. The park was aging, George Long was looking to step back from the operations, and the rising value of the waterfront property prompted him to consider selling the land for condominium development.

But Long's five grandchildren could not bear to see his life's work vanish. They approached him about taking over the facility, and in 1975, the park was transferred to a new management company led by Rob, Anne, George, and John Norris and Suzy Price, the family's fifth generation to work in the industry. It was almost fitting that this transfer occurred almost 100 years after the family entered the business with its first carousel.

The new generation brought a renewed vigor to the park as it neared its centennial. They changed the park's name back to Seabreeze, adopting a one-word version of the original two-word name, and immediately set out to upgrade the aging facility. Old rides and structures were renovated or replaced, operations upgraded, and new attractions were added, including the Gyrosphere, Manhandlers, Kids Kingdom, and the Log Flume. Meanwhile, its oldest attraction, the Jack Rabbit, received a six-year renovation starting in the 1980s.

While the park was enjoying a renaissance under the new generation, George Long did not completely walk away from the business. He maintained a shop in the basement of the carousel building where he kept himself busy carving full-size and miniature carousel animals, including two complete miniature carousels. He was considered one of the last old-school carousel carvers.

The revival of the park was well timed, as the late 1970s and early 1980s were again a difficult period for parks like Seabreeze. The industrial economy in the Northeast and Midwest was in decline, leading to a loss of the critical group picnic business for many of Seabreeze's peers. While many of them could not survive this downturn, Seabreeze's future was bright with a renewed energy as it entered the 1980s.

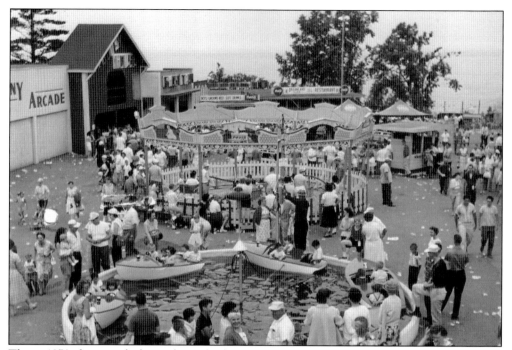

This c. 1970 photograph shows the park when it was open exclusively for employees of Bausch & Lomb. During this period, the park featured several kiddie rides in its north end, including the kiddie boats and, behind them, the Turtles, a kiddie version of the old Lightning Bug ride. The Goofy House and Ghost Train can be seen in the background. (SB.)

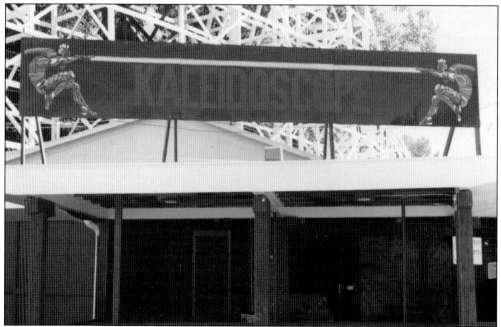

One of the first changes at the park in the 1970s was the conversion of the Subway into the Kaleidoscope in 1972. In keeping with the times, the ride was transformed into a colorful psychedelic light show. The Kaleidoscope remained in operation until 1982. (SB.)

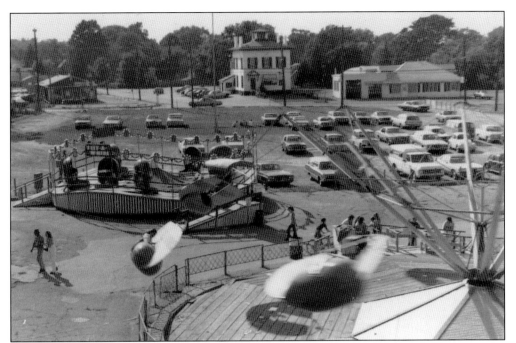

For much of its early existence, Seabreeze did not have a fence surrounding it, and visitors came and went as they pleased. As times changed, this arrangement became increasingly impractical, as it was difficult to control the crowds. When the new generation of family members took over the property in the mid-1970s, they started the process of fencing the park. (SB.)

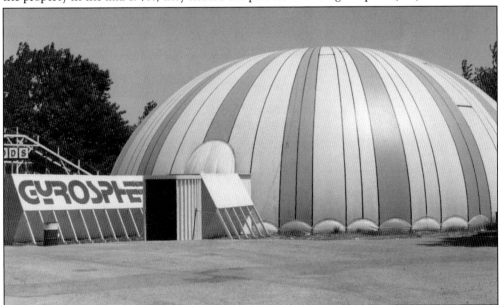

One of the first rides added by the new generation was the Gyrosphere in 1976. A Scrambler ride was enclosed in a large inflated dome, and an elaborate light show was performed using two 200-watt speakers, nine projectors (including six mounted on the ride), and mirrored balls. The Gyrosphere debuted with the Electric Light Orchestra song "Fire on High," which became synonymous with the ride. It remained in operation until 2007. (SB.)

Throughout the 1970s, the new generation of family members upgraded the park and introduced new attractions. Following the Gyrosphere, in 1978, the Manhandlers ride was added next to it. Manhandlers was a Whizzer ride manufactured by the King Amusement Company of Michigan and featured a spinning tub at the end of a long undulating arm. Each tub was painted to resemble a Campbell's soup can. (SB.)

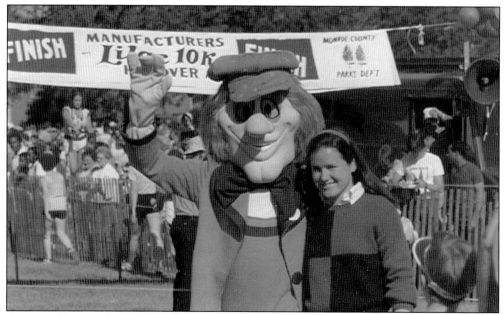

As the influence of corporate-owned theme parks spread throughout the industry, the use of costumed characters as mascots became common. Seabreeze was no different, and in 1976 introduced C. Breezy to Rochester. Promoted as a hip inventor who came to Seabreeze with new ideas and innovations, for many years he was a regular presence at the park, greeting guests and appearing in shows. (SB.)

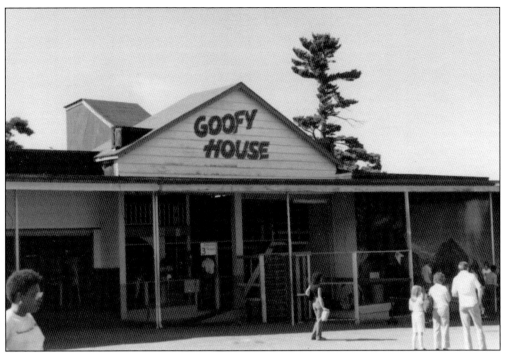

As the years went by, the Goofy House maintained a constant presence on the midway. Due to changing tastes and evolving safety standards, changes had to be made, but by the 1970s, it had largely taken the form it would maintain as one of the last remaining examples of a fun house until it was destroyed in a fire in 1994. Favorite features included a rotating barrel, dark walkways, and a large slide from the second floor to the midway. (Both, SB.)

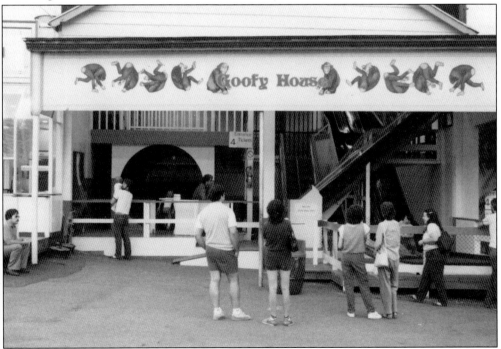

The Goofy House was not the only midway staple that evolved in the 1970s. In 1978, as part of the general upgrades the new generation was making to the park, the Ghost Train was rethemed to a new dark ride. Dubbed the Enchanter, the ride maintained the distinctive pretzel-adorned cars and basic layout but had an all-new theme based on Merlin the wizard. The tower in front became a prominent landmark, while the ride had several unique scenes, including one made out of repurposed traffic cones. One of the more notable scenes was the talking heads, seen below. The Enchanter was removed in 1985, and the space was converted into a shooting gallery. (Both, SB.)

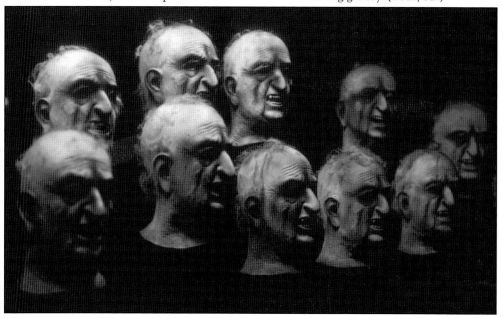

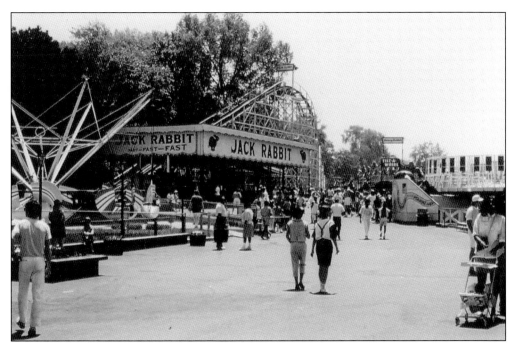

In 1979, a new fixture was added to the south end across from the Jack Rabbit. The Round Up, seen here to the right, was manufactured by Frank Hrubetz and Company. Riders stood up against a wall and the ride rotated; as the ride tilted, centrifugal force would keep riders in their positions. The Round Up operated at Seabreeze until 1997. (JF.)

In the late 1970s, interactive play areas became an emerging trend in the industry. In 1981, after a year of planning, Seabreeze opened Kids Kingdom, seen behind the Crazy Cups, with its four distinct towers. A large interactive play area, it featured 14 activities, including a ball crawl, a cube maze, a log mountain, slides, rafts, an inflatable bounce, and cargo nets to climb. It replaced the Hot Rods ride. (JF.)

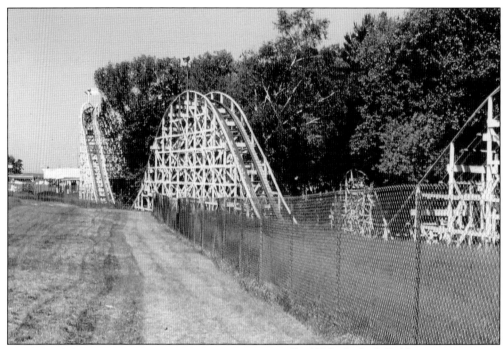

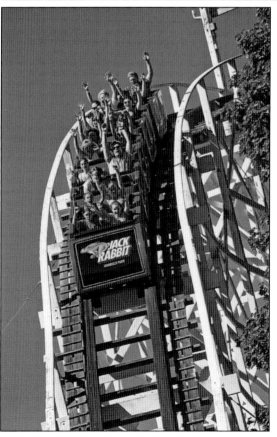

By 1980, the Jack Rabbit was entering its seventh decade of operation. Despite being 60 years old, it remained one of the park's most popular rides and was due for an overhaul. The park began a six-year project to renovate the aging ride, replacing much of the wood and upgrading the mechanical system to ensure it would remain a favorite for generations to come. As part of the project, the Kaleidoscope, which had wound underneath the Jack Rabbit since it was built in 1920, was removed, along with the former home of longtime Jack Rabbit operator Jack Kirby, which sat under the Jack Rabbit lift hill. A few years after the rehab was completed, the park replaced the trains in 1989 with an all-new set from Morgan Manufacturing. (Above, JF; left, SB.)

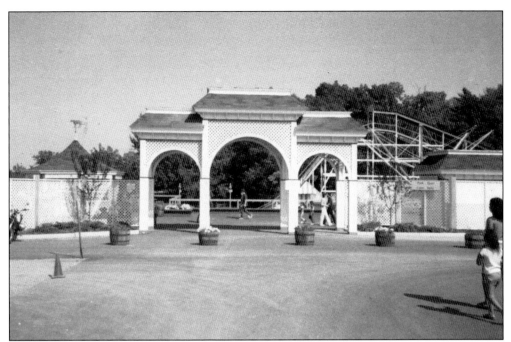

With the park's transformation in full swing in the early 1980s, Seabreeze began upgrading its infrastructure. A key component in 1983 was the addition of this new Victorian-themed entrance gate that reflected the park's nostalgic atmosphere. As Seabreeze has continued to grow, the entrance has kept its personality as it has been expanded. (SB.)

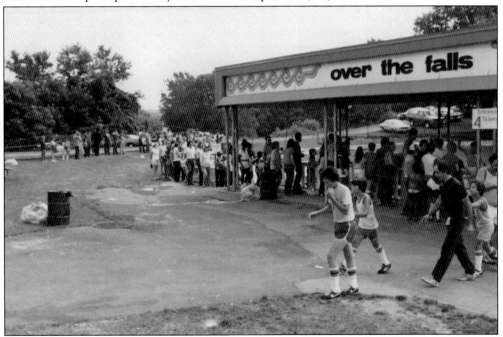

By the early 1980s, the unique Over the Falls was becoming an operational and maintenance challenge. But as seen here in 1980, it remained a popular attraction, particularly on a hot summer day, when the line stretched out into the midway. (SB.)

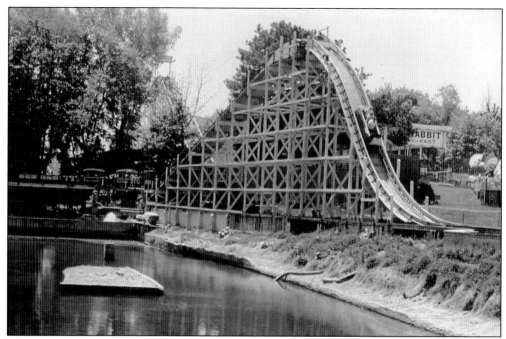

The solution was not to remove Over the Falls but to modernize it by converting it to a new Log Flume ride in 1984. Seabreeze hired O.D. Hopkins Associates of Contoocook, New Hampshire, to manufacture the new ride. The original 40-foot-tall hill was retained, and a new 1,200-foot-long trough was constructed. The plunge over the hill measured 55 degrees, one of the steepest drops on any log flume. (JF.)

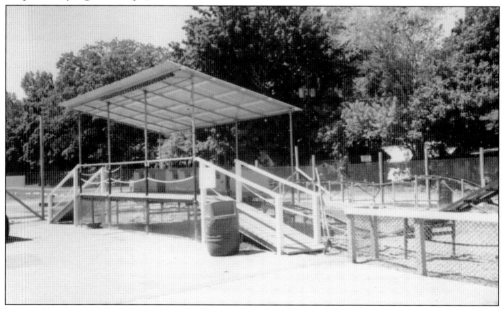

In 1985, a new kiddie coaster joined the lineup at Seabreeze. Named the Bunny Rabbit, it was built across from its larger namesake and was a Little Dipper model manufactured by the Allan Herschell Company. Seabreeze purchased the ride from Enchanted Forest in Old Forge, New York. (SB.)

84

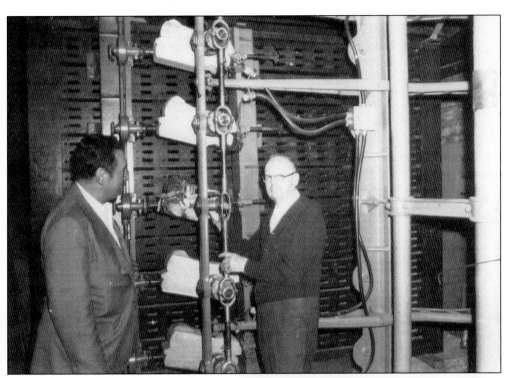

Although George Long had stepped back from operating Seabreeze, he was still a fixture at the park. In the 1960s, he was able to obtain an old carving machine from the Philadelphia Toboggan Company that he had used when he worked at PTC in the early 1900s (above). Well into the 1980s, he kept himself busy making replacement parts for the carousel and even carved 30 to 40 full-size animals that he sold for $500 each. Since he was one of the last examples of a lost American art form, Long was featured in *On the Road with Charles Kuralt* and invited by the Smithsonian Institution to demonstrate his carving skills at the National Museum of American History in 1981. (Both, SB.)

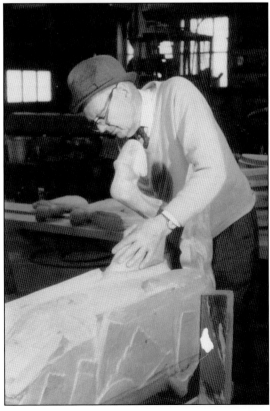

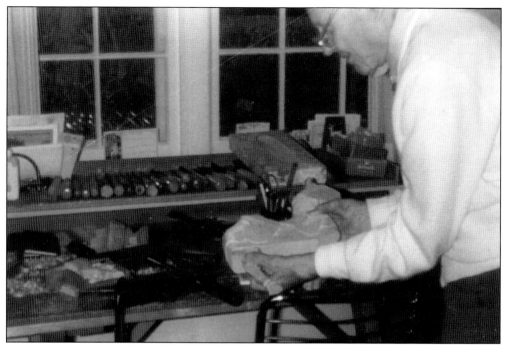

By the 1980s, George Long was focused on carving 13-inch-long miniature carousel animals. He worked on five at a time and produced over 600 during his lifetime. In addition, he carved two complete miniature carousels. The first, completed in 1977, was a replica of the park's PTC No. 36 machine and took over 2,000 hours to construct. He completed a second miniature carousel in 1986 at the age of 94, which took over 3,000 hours of work. (Both, SB.)

Five

MAKING A SPLASH
1986 TO 1993

By the mid-1980s, Seabreeze was on solid footing, having successfully transitioned to a new generation of operators and having survived the hard times that claimed so many of its peers. Business had grown continuously for a decade, but again, changes in the industry required a response from the park.

Competition was increasing from large corporate-owned theme parks appearing in the region, while new attractions such as waterparks were competing for consumer time and dollars. In 1978, the first freestanding waterpark, Wet 'n Wild, opened in Orlando, and soon traditional amusement parks were starting to add waterslides. In 1983, Geauga Lake in Aurora, Ohio, changed the industry by combining a full-scale waterpark with an amusement park in one facility. As a result, amusement parks throughout the country were adding waterparks to their attractions lineups, and in 1986, Seabreeze followed suit with its largest expansion ever.

Over the next three seasons, the park constructed a four-acre waterpark on undeveloped property in the back of the facility at a cost of $1.2 million. The first phase included three water slides, a changing room, food stands, and merchandise outlets. This was followed in 1988 with an activity pool and two waterslides for children. The waterpark was a huge success, leading to a 25-percent increase in attendance.

While the waterpark accounted for the bulk of the investment, new rides did continue to appear, including the Yo-Yo and Sea Dragon. But this also marked the end of an era, as Seabreeze charged admission for the first time in 1986, ending the tradition of a free gate. In addition, George Long, who continued to be a visible presence in the park despite his advancing age, passed away in 1988 at the age of 96. But he had left Seabreeze in good hands, and as one era ended, a new one began.

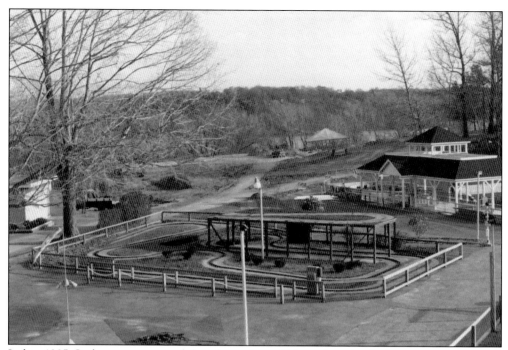

In late 1985, Seabreeze announced that the park would be undergoing its largest expansion ever, a multiphase development of a waterpark. Waterparks in amusement parks were still relatively rare at the time, but Seabreeze thought that adding one would be the perfect way to stand out in an increasingly competitive market. The $1.2-million project was placed on a four-acre site on the eastern portion of the property beyond the Log Flume. The initial phase included changing rooms, food outlets, and an admission building, along with a 50-foot-tall slide tower. (Both, SB.)

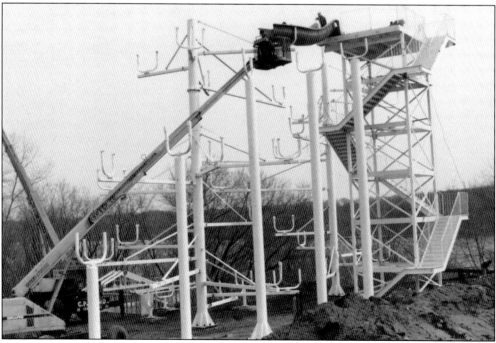

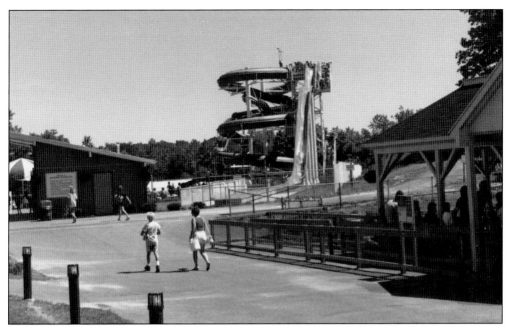

Phase one opened in June 1986 and was anchored by three waterslides. Two of the slides were body slides, providing a twisting 400-foot journey into the splashdown. The third, named the Banzai Speedslide, shot riders straight down a 250-foot run at speeds up to 35 miles per hour. The waterpark was a huge success, with attendance skyrocketing despite admission being charged for the first time. (SB.)

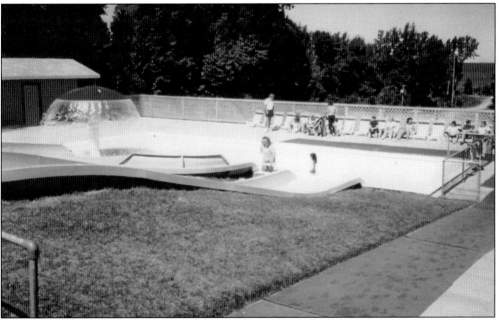

The next phase of the waterpark opened mid-season in 1988 and was targeted at the park's younger visitors. It featured two small slides—Mini-River and Mini-Twister—as well as a shallow pool called the Cascade Activity Pool, later known as Loony Lagoon. A new sun patio was also installed. (SB.)

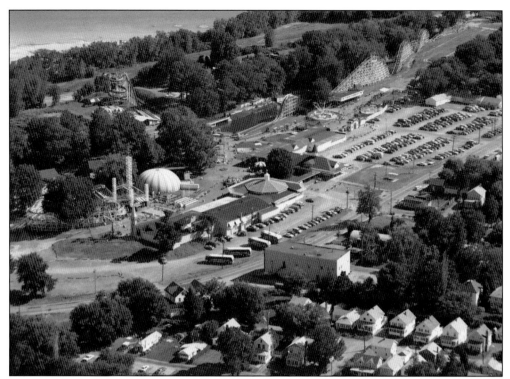

This aerial view shows Seabreeze shortly after the first phase of the waterpark was completed. The waterslides can be seen at upper left near Irondequoit Bay. Other notable recent additions include the striped dome of the Gyrosphere, with the towers of Kids Kingdom standing next to it. The Victorian-themed front entrance is at upper right, just in front of the Flying Scooters. (SB.)

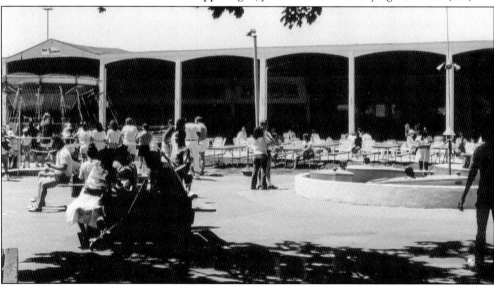

Children not only had a new area in the waterpark in 1988 but also a new ride. A kiddie swing ride manufactured by Sartori, an Italian ride manufacturer, debuted in the kiddieland in the center of the park. As seen here, the kiddie boat ride had also been relocated from the north end of the park several years earlier. (SB.)

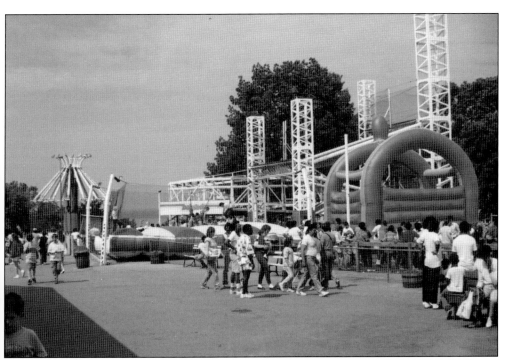

The Rock-O-Plane was replaced by the Yo-Yo in 1989, providing a swing ride for the park's bigger guests. Erected at the far north end of the park, it provided a great view of Lake Ontario during the ride. Kids Kingdom remained a dominant feature with its array of participatory activities. (JF.)

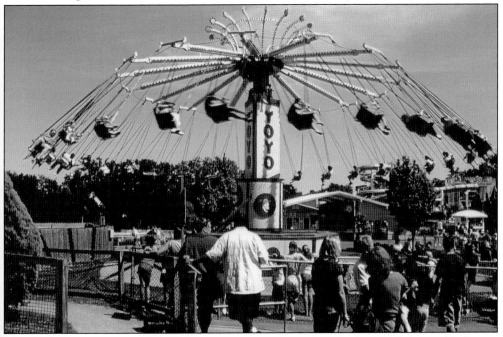

The Yo-Yo was manufactured by Chance Rides of Wichita, Kansas, one of the world's largest manufacturers of amusement rides. After spending its first five years at Seabreeze at the north end of the park, it was relocated next to the waterpark in the mid-1990s. (JF.)

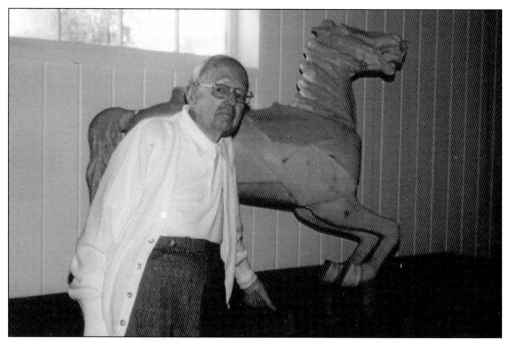

On September 27, 1988, George Long passed away at the age of 96. He had a remarkable 84-year run at Seabreeze, starting as a child as a concessionaire and working his way up the ladder, operating his own concessions, building attractions, becoming manager, and eventually coming to own the park. He shepherded Seabreeze through good times and bad and passed it along to the next generation of family members, assuring Seabreeze would thrive for years to come. Up to the end, he was a fixture at the park, carving carousel horses, offering advice, and helping to maintain the carousel, his favorite ride. (Both, SB.)

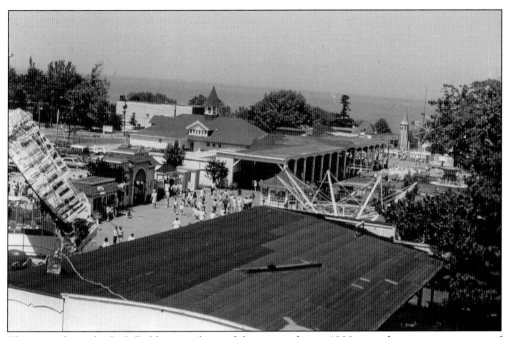

This view from the Jack Rabbit on a beautiful summer day in 1988 provides a great overview of Seabreeze looking north to Lake Ontario. The roof of the Jack Rabbit station is in the foreground, with departed rides such as the Round Up and Rock-O-Plane visible along with rides that still remain, like the Tilt-A-Whirl and Flying Scooters. (JF.)

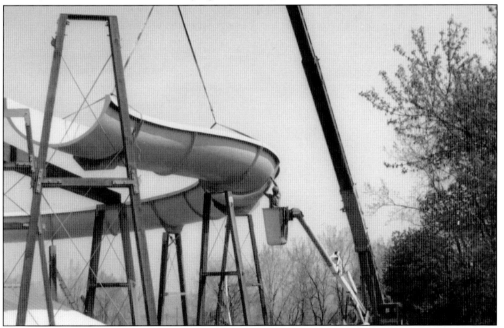

Expansion in the waterpark resumed in 1990 with the construction of two major attractions that doubled its size. The first, Riptide, was a massive inner-tube slide in which riders in one- or two-person inner tubes traveled down a 500-foot-long waterslide. Riptide started atop its own newly constructed tower, with the new slide wrapping around the original slide tower. (SB.)

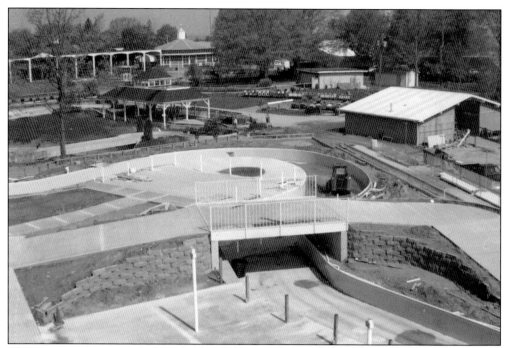

The second addition was the Lazy River ride. A meandering 600-foot-long river, its slowly drifting inner tubes provided an excellent, low-key way to cool off on a hot summer day. At the center of the Lazy River was Paradise Island, an area that featured chaise lounges for sunning and a water splash area that drained into the Lazy River. The two projects brought the total investment in the waterpark to over $3 million. The waterpark had grown to the point where it was now promoted as its own attraction, Raging Rivers. (Both, SB.)

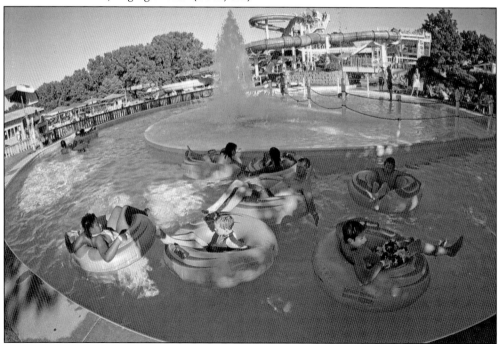

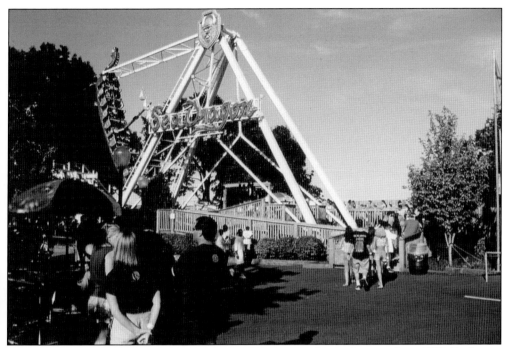

By the early 1990s, Kids Kingdom was aging and losing popularity. As a result, in 1991, Seabreeze replaced it with the Sea Dragon, a swinging ship ride manufactured by Chance Rides. Seabreeze acquired the ride from Conneaut Lake Park in Pennsylvania. (JF.)

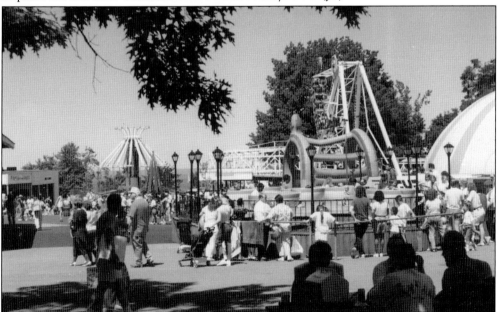

A view of the north end in the early 1990s shows the recently installed Yo-Yo in its original location along with the Sea Dragon. When Kids Kingdom was removed, the park knew that younger guests still enjoyed the participatory nature of its activities, so it also added the Rainbow Bounce, the arch-shaped structure between the Sea Dragon and Gyrosphere. It was at the park until 1998. (SB.)

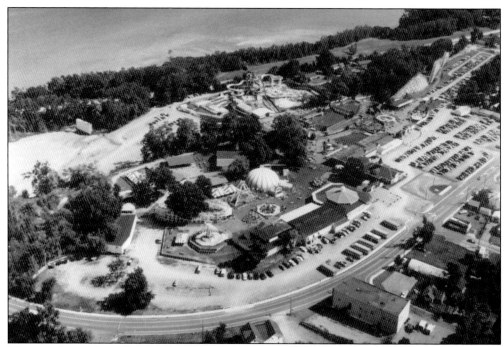

This aerial view dates from 1991 and shows how much the waterpark had grown, along with the location of new additions such as the Yo-Yo and Sea Dragon. (SB.)

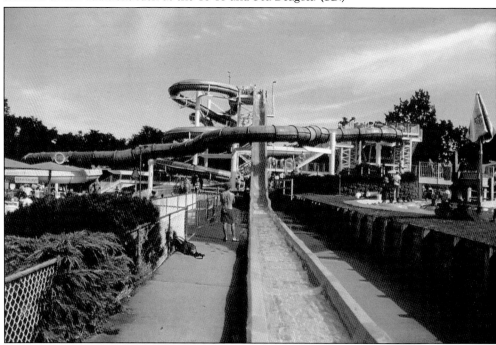

In 1992, Raging Rivers added a second tube slide, the Vortex. The 410-foot-long slide, along which riders traveled on single-passenger inner tubes, was completely enclosed, the last third in total darkness. The new slide was built off the same tower that the Riptide utilized, crossing in front of the original water slide tower and over the Banzai Speedslide. (JF.)

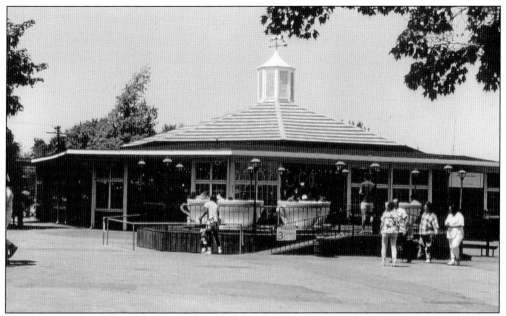

By the early 1990s, Seabreeze's future was bright. The new generation had revitalized the facility, and while many new attractions were added, tradition was still an important part of Seabreeze's identity. At the heart of the park was the carousel building constructed by the Long family in 1915, although it had been modernized over the years. (JF.)

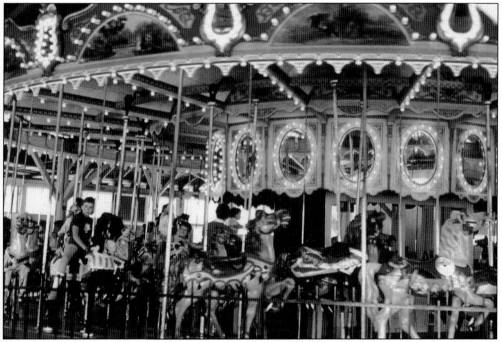

The carousel was the soul of Seabreeze. It had been owned by the Long family since it was purchased by George Long Sr. for $7,800 in 1915 and was a fixture at Seabreeze since it was moved there in 1926 from nearby Seneca Park. The ride was George Long Jr.'s favorite, and he kept it in top-notch condition, a tradition passed on to his granddaughter Suzy Price Hofsass. (JF.)

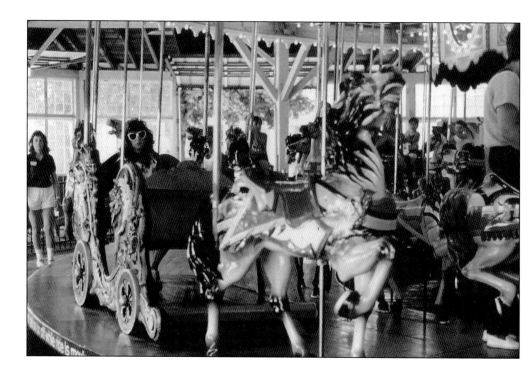

The ride was known as PTC No. 36, as it was the 36th carousel manufactured by the Philadelphia Toboggan Company. It featured 48 horses hand-carved out of poplar, along with two chariots. It was widely recognized as one of the finest examples of the carousel art. (Both, JF.)

The carousel building was so much more than a place to house a ride. It featured several historical exhibits and housed one of the miniature carousels that George Long made. A favorite of guests were these Adirondack rocking chairs, which allowed people to relax and enjoy the one-of-a-kind colorful sight and sound show that was PTC No. 36. (JF.)

The carousel was one of several buildings along the west side of the park's north end that were fixtures for decades. Next to the carousel was an old roller rink that had been converted into an arcade and a refreshment stand. Then, as seen in this view from 1988, came the Goofy House and the shooting gallery that had originally been home to the Ghost Train. The distinctive tower was added when the Ghost Train became the Enchanter. (JF.)

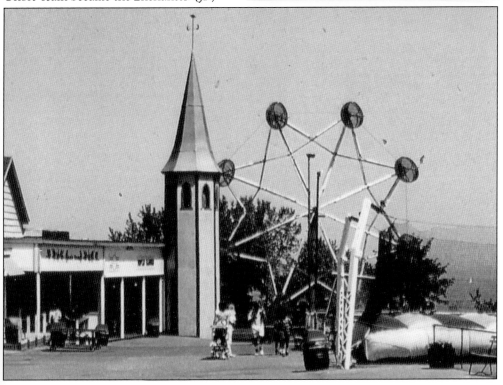

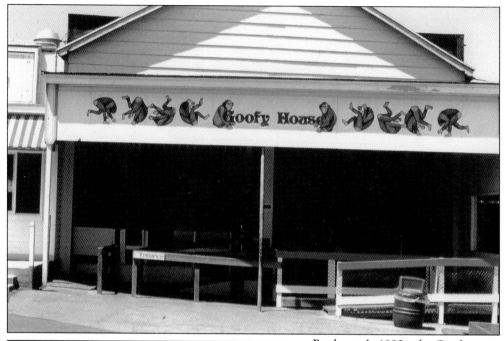

By the early 1990s, the Goofy House, a fixture since 1949, was a rare attraction in the industry. Fun houses like it used to be very common, but as many of Seabreeze's peers fell victim to changing times and the rise of the corporate theme park, fun houses began disappearing. The Goofy House was not totally immune to these changing times, and the park had to make concessions to meet modern safety standards, but it was still a favorite, with features like its slide. (Both, JF.)

Six

UP FROM THE ASHES
1994 TO 2004

March 31, 1994, was a typical spring day for Seabreeze amusement park. Work crews were scrambling around the park to prepare the facility for its 116th season, including one crew making repairs to the roof of the arcade building. Shortly after 3:00 p.m., flames were spotted coming from the structure. Despite the efforts of 175 firefighters, less than two hours later, 10 percent of the park had been lost, including the Goofy House, the arcade, a food stand, and maintenance shops.

But the most devastating loss was the soul of Seabreeze, the antique carousel that had been a park fixture since 1926. It represented one of the finest examples of the carousel art and had just been voted one of the top five carousels in America by the National Carousel Association. Also lost were the miniature carousels carved by Long, along with his antique carving machine.

But Seabreeze knew the show had to go on, and the site was quickly cleared and plans made to rebuild. In fact, the season opening was only delayed by two weeks. A tent was erected as a temporary home for the arcade, and by the end of July, a new roller coaster, the Quantum Loop, opened.

By 1995, new buildings were opened, but replacing the carousel was a special challenge. The easy choice would have been to purchase a modern carousel with fiberglass animals, but the family knew that would not be a sufficient tribute to the legacy of their ancestors. As a result, they took the opportunity to construct an entirely new wooden carousel. In the end, it became the ninth carousel created by the family and a fitting tribute to the family's entry into the industry more than a century earlier.

With a new carousel spinning at Seabreeze in the same location as PTC 36, growth resumed, including new rides and attractions like Bear Trax, the Screamin' Eagle, Soak Zone, and The Wave. As Seabreeze entered the 21st century, changes were again roiling the industry: a wave of corporate-driven consolidation was prompting many family-owned parks to sell. But not so for Seabreeze—it was truly on a roll.

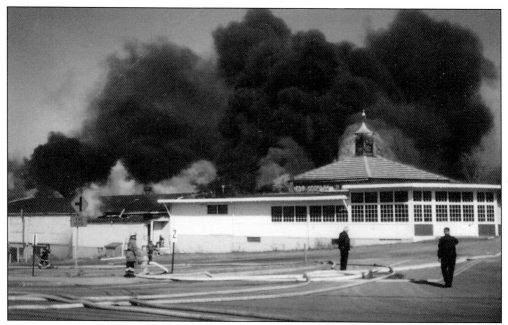

On March 31, 1994, as Seabreeze was preparing for the season, flames were spotted on the roof of the arcade building, dating to the early 20th century, when it was built as a roller rink. Flames quickly spread through the old 300-foot-long wooden structure, which was undergoing repairs. The fire was reported at 3:06 p.m., and over 175 firefighters responded. The fire department had drilled at the park in the past and knew how to position equipment to contain damage, but it could not prevent the flames, driven by 25-mile-per-hour winds, from spreading north to the Goofy House, pizza shop, gift shop, and shooting gallery and south to the 89-year-old carousel building, home to the park's pride and joy. By the time the fire was brought under control at 4:47 p.m., Seabreeze was changed forever, and 10 percent of the park was gone. (Both, SB.)

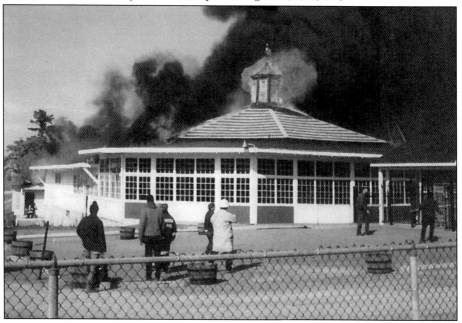

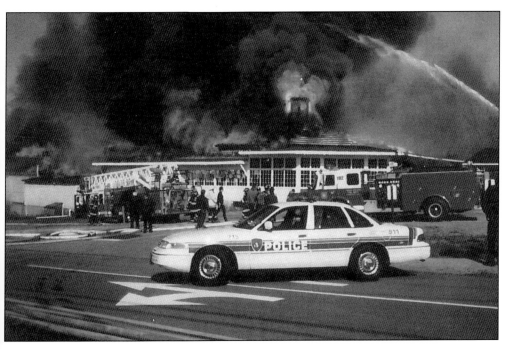

The carousel was a complete loss, with only the charred remains of the center pole providing any sign of what had been there. Some of the other losses were obvious—the Goofy House, arcade, and shooting gallery—but others were not. A maintenance area was located underneath the arcade. In addition, the PTC carving machine and George Long's miniature carousels were among the losses. Nearby, the extreme heat tore open the Gyrosphere's dome and damaged the Yo-Yo, Crazy Cups, and Bobsleds. But in the true show business spirit, Seabreeze knew it had to move on. It was too important to the community. (Both, SB.)

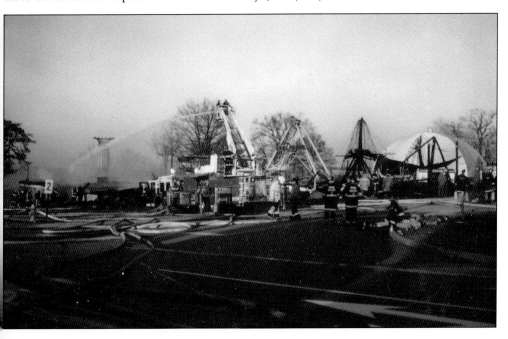

Since it was the off season, many of the ride vehicles were stored in the arcade building and were lost, including those of the Log Flume, Flying Scooters, and T-Birds. In the spirit of the industry, other amusement parks rallied to support Seabreeze and shipped the park surplus equipment. Kennywood near Pittsburgh, Pennsylvania, gave Seabreeze the cars from a Flying Scooters ride it had in storage, getting that classic back in operation quickly. (JF.)

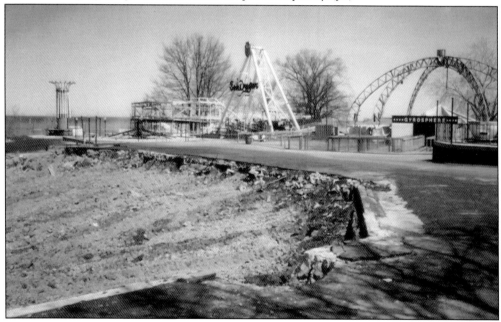

While the season's opening was delayed for two weeks, cleanup and recovery began immediately. It was not long before the debris was cleared and new blacktop laid on the midway. In the background, the Gyrosphere is stripped of its damaged covering. In addition, a portion of the Bobsleds structure was blackened by the intense heat. (SB)

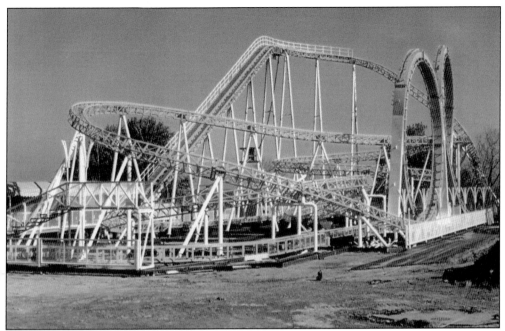

At the time of the fire, Seabreeze had been planning to add a new roller coaster for the 1995 season. It had even located one in France that it was planning to acquire. But with the north end in need of a new attraction, the park accelerated those plans. Built in 1983 by the French firm Soquet, the coaster was used at Paris-area fairs before Seabreeze purchased it. It stood 75 feet tall with 2,822 feet of track, two 58-foot-tall loops, a 720-degree horizontal helix, and a top speed of 56 miles per hour. The 840,000-pound ride was moved from France in 13 containers, leaving the week of June 20. It arrived in Montreal a week later, and was hauled by truck to Rochester, where it arrived between July 5 and 7, opening two weeks later. (Both, SB.)

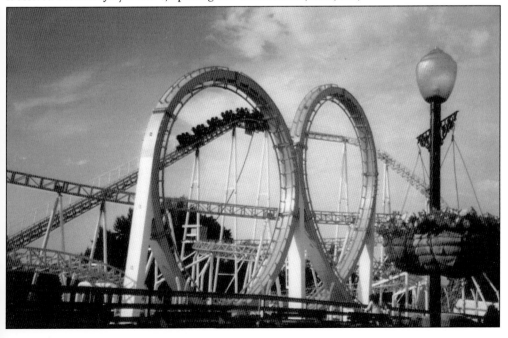

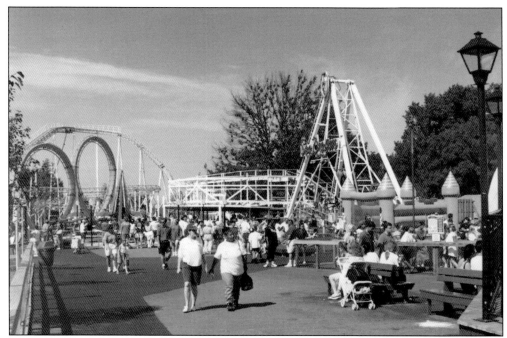

The Quantum Loop's bright yellow tracks made an immediate impact on the park's north end and sent a powerful signal that Seabreeze was not going to let the fire slow it down. It was a dramatic change to the ever-evolving view of that end of the park. During construction, Seabreeze unearthed the foundations of the old Sky Ride. (SB.)

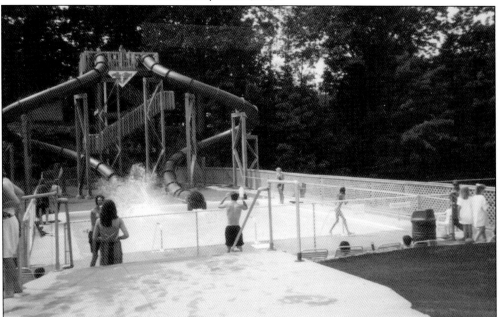

The Quantum Loop was not the only new attraction at Seabreeze that season. In April, it received planning approval to add two more waterslides to Raging Rivers. Named Wipe Out!, the new slides were erected on a previously unused area and consisted of two enclosed, serpentine waterslides that drop from a 40-foot-tall tower. (SB.)

During the 1994 season, Seabreeze erected a tent to hold a revived arcade, but soon plans were being made to rebuild the affected area. The first phase of the reconstruction was a new 5,000-square-foot building to house a new arcade, food outlet, and restroom. It featured a 39-foot-high open ceiling with skylights. (JF.)

Given that the original carousel building was the heart of Seabreeze, it was critical that the new structure have that same personality. As a result, a new $300,000 octagonal building replicating a vintage carousel building was erected on the site of the old one, featuring nine roll-up doors, a fire suppression system, and a cupola with a gold-leafed carousel horse weathervane. (SB.)

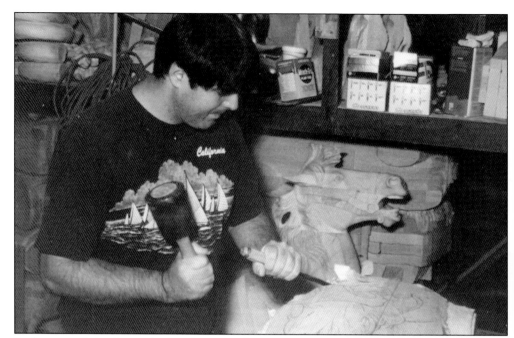

Seabreeze took its time replacing the carousel, as it was important that the heritage of PTC No. 36 and the family's century-plus legacy in the industry be respected. Finding another antique carousel would have been difficult and expensive, while the easy solution, purchasing a modern machine with fiberglass horses, just did not seem right. As a result, Seabreeze decided to create its own wooden carousel. Park president Rob Norris and his brother George evaluated eight manufacturers and a dozen carvers and hired Ed Roth of Lakewood, California, to carve the new horses in a manner reflective of vintage carving styles. It took Roth 14 months to create 40 new horses and two chariots. (Both, SB.)

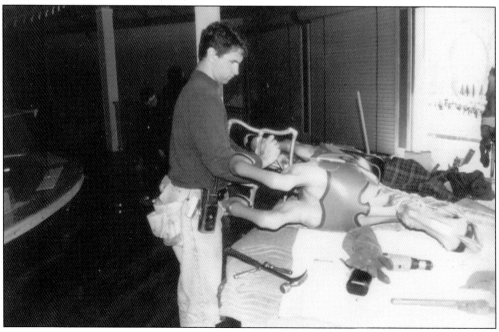

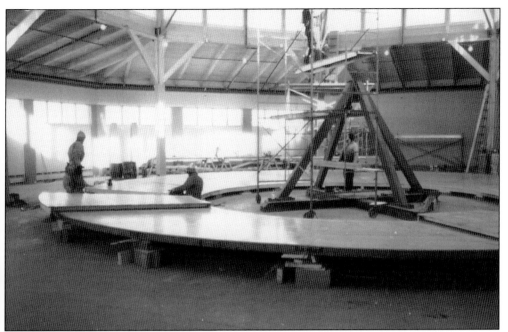

The 40 newly carved horses, along with four from PTC No. 36 that were not on the ride at the time of the fire, and two horses carved by George Long, were placed on a carousel frame created from PTC No. 31. The frame was originally built in 1914 for Lakeside Park in Dayton, Ohio. After that park closed in the 1960s, the ride remained in storage until 1990, when the horses were sold off to collectors. For Seabreeze, it was the perfect opportunity, as PTC No. 31 was very similar in size and age to PTC No. 36. While all the wooden parts from the PTC No. 31 frame were replaced, some metal parts, such as cranks and gears, were used in the new ride. (Both, SB.)

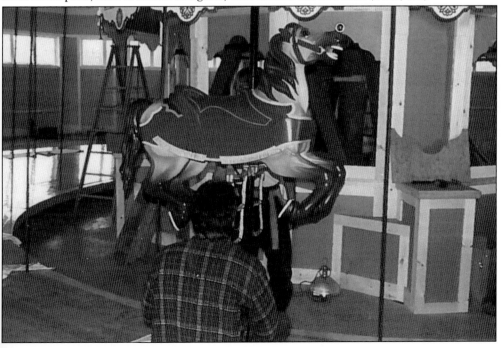

The new 42-foot-tall building was a welcome presence on the midway when it opened in 1996. At 86 feet wide, it was slightly larger than the original, allowing room for historical displays and 30 red rocking chairs. Recreating the original red rockers was a challenge, as plans did not exist and they had to be rebuilt from memory. It took three prototypes to get it just right. (JF.)

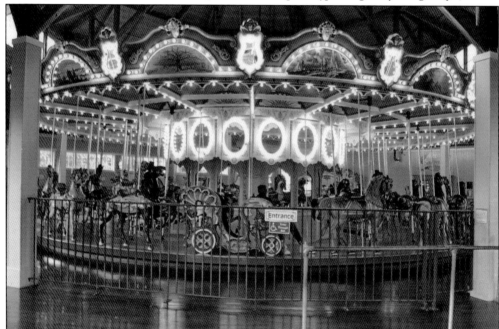

In addition to the horses, the frame received updated mechanical and electrical systems. New rounding boards and scenery panels around the top of the frame, new shields, and center sections were created by the Seabreeze staff, led by George Norris and a team of craftpersons and artists after extensive research. It was adorned with 1,170 light bulbs. (JF.)

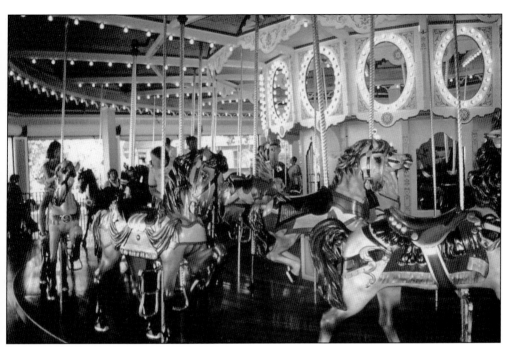

The $500,000 carousel is unlike any other. The completed ride, which opened in 1996, featured a total of 46 horses. Similar to the carousels manufactured by the Philadelphia Toboggan Company nearly a century earlier, the new ride also incorporates the style of the late master carver Daniel Muller and the unique style of Ed Roth. The park did not seek to replicate an antique carousel but rather to "pay tribute to the grand tradition of the Philadelphia-style carousel," according to Rob Norris. (Both, JF.)

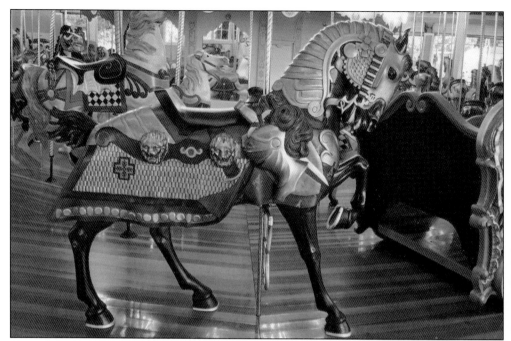

One of the most beautiful horses is the armored horse. This is a traditional feature on the Philadelphia-style machine, reflecting the carousel's origin as a training device for medieval knights. In the end, what started as a tragic loss became a unique opportunity for the descendants of Edward Long to continue a century-plus family tradition of making carousels. Seabreeze's new ride became the ninth carousel created by the family. (JF.)

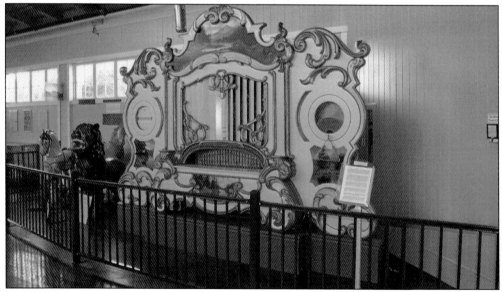

It was also important to maintain tradition in the music that accompanied the new ride. Since Wurlitzer stopped manufacturing band organs in 1942, the park again had to create its own. Seabreeze hired J. Verbeeck Organ Manufacturing of Belgium to create a replica of a Wurlitzer 165 like the one that was lost. The park was able to locate parts of an original Wurlitzer 165 and music rolls to make the project feasible. (JF.)

By the mid-1990s, the Bunny Rabbit was aging. Seabreeze knew it wanted to maintain a roller coaster that its youngest guests could ride, and for the 1997 season introduced Bear Trax, an all-new kiddie coaster. Built by E&F Miler Industries, a leading manufacturer of kiddie roller coasters, the ride stands 12 feet tall, has a 16-foot maximum drop, and provides a zippy ride along 380 feet of track. Bear Trax was erected on the former location of the Bunny Rabbit, across the midway from its big brother, the Jack Rabbit. The site was planted with evergreens and maples. The ride anchored a $600,000 improvement program in 1997 that also included a new park maintenance shop. (Both, JF.)

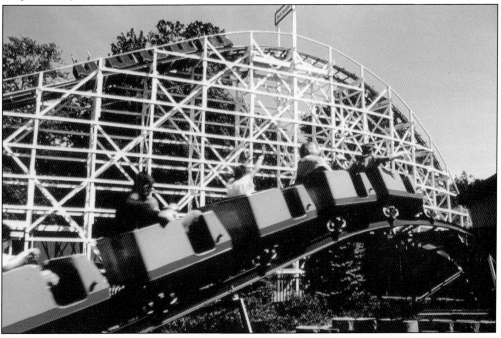

The upgrades continued in 1998, with the Round Up giving way to the Screamin' Eagle, manufactured by the Italian firm Zamperla. The 70-foot-tall ride takes 24 riders, with their feet dangling free, and flips them upside down at speeds of up to 11 revolutions per minute. (JF.)

The park's investment program returned to the waterpark in 1999 with the addition of Soak Zone. Dubbed "the ultimate sprayground," the attraction featured various interactive devices, including water cannons operated by compressed air, water guns that spray at other guests, geysers that shoot water in patterns, fountains, and a giant bucket that dumps hundreds of gallons of water on guests waiting below. Soak Zone also featured three kiddie waterslides. (SP.)

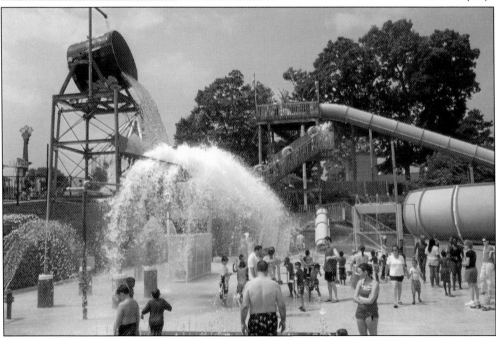

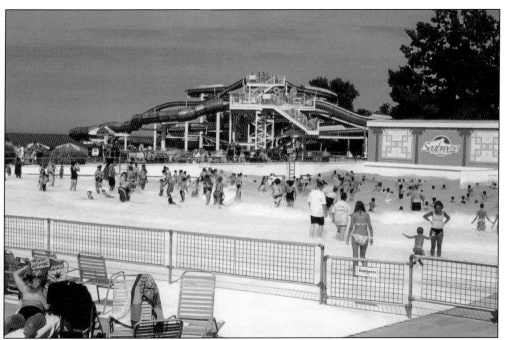

Seabreeze's first attraction of the new century was a wave pool, The Wave. Developed in 2001 in an area that had been occupied by several houses where the family lived, the 15,000-square-foot pool held over 260,000 gallons of water and had a depth of up to five feet. A computer-controlled blower system was capable of generating five different wave patterns, with waves up to four feet high. The 1.5-acre site also included a sun deck with over 100 chaise lounges and beach chairs. The Wave was built by Wave Tek of Cohoes, New York, and the installation was done by Express Construction of Chicago and park staff. (Both, SB.)

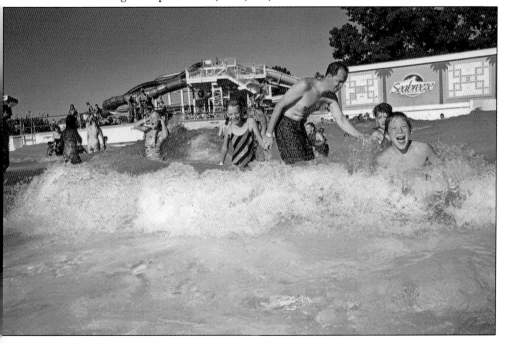

A new type of ride, the drop tower, took the industry by storm in the 1990s; in 2003, Seabreeze added its own version. The Spring, manufactured by Moser Rides of Italy, was a family version of the ride that provided a bouncing motion as the 10-seat car traveled up and down the tower. (JF.)

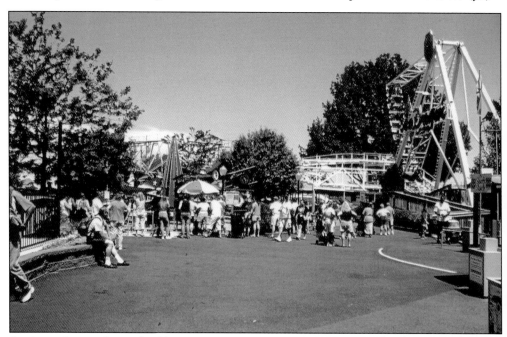

As the park moved into the 21st century, more resources were put into landscaping. This view of the north end from 2004 shows how much Seabreeze had moved beyond the sea of blacktop seen just a few decades before. At the center of the image is the Barnstormer, a kiddie airplane ride that debuted in 1991. (JF.)

Seven

A ROCHESTER TRADITION
2004 TO 2018

By the turn of the millennium, Seabreeze had truly established itself as a regional institution. It had survived economic downturns, world wars, ownership changes, aging facilities, devastating fires, shifting consumer tastes, and the rise of the corporate theme park chains. Under the careful stewardship of the Long-Norris-Price family, it has been modernized to remain relevant but still maintain the nostalgic atmosphere that is so rare today.

In 2004, Seabreeze became just the eighth amusement park in the United States to celebrate its 125th anniversary, a true testament to its enduring popularity. It celebrated with the addition of the Whirlwind, a new generation of roller coaster where the cars spin freely through the twists, turns, and dips.

Since that time, Seabreeze has continued to change and improve. New attractions have appeared on a regular basis. Some, such as the Helix and Hydro Racer, were added to the waterpark, while others, such as Music Express, Revolution 360°, Twirlin' Teacups, Balloon Race, Wave Swinger, and Time Machine appeared in the ride area of the park. In many cases, they replaced existing rides, reflecting a new challenge for the increasingly popular 35-acre institution—limited space.

Today, Seabreeze is thriving. A summer visit is a beloved Rochester tradition. As they have since the beginning, a wide array of groups fill the picnic grounds on summer afternoons. Families create new memories on rides and attractions their predecessors enjoyed, and a new generation of Norrises is taking on increasing responsibility, ensuring that the park and the family remain a vital part of the amusement park industry.

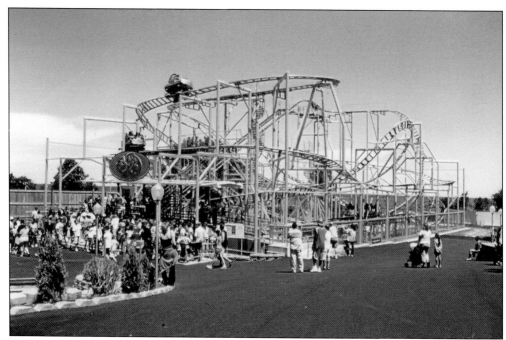

By the early 2000s, Seabreeze was looking for a new roller coaster that would appeal to a wider array of riders than the looping track of Quantum Loop. It celebrated its 125th anniversary in 2004 with the introduction of the Whirlwind. Manufactured by Maurer-Söhne of Munich, Germany, Whirlwind seats passengers back-to-back and four to a car, which starts to rotate partway through the ride. Based on the number and weight of the passengers, each ride is different, with up to 20 rotations per minute. The $2-million ride stands 51 feet tall and has 1,391 feet of track, with a top speed of 38 miles per hour. (Both, JF.)

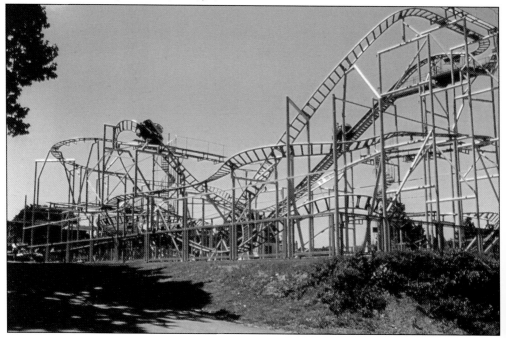

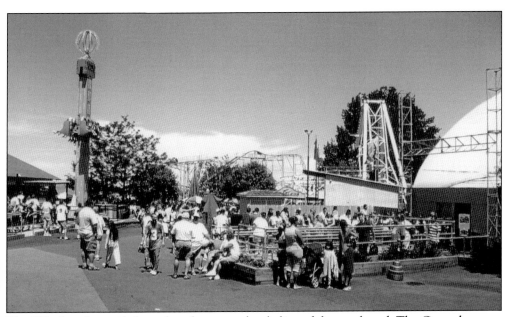

The Whirlwind provided another change to the skyline of the north end. The Gyrosphere, on the right, still remained a favorite ride and in 2002 underwent an upgrade that included a new light show and, for the first time in at least a decade, a new tune, "Gyro Mix" by DJ Tornado taking the place of the iconic "Fire on High" by ELO. (JF.)

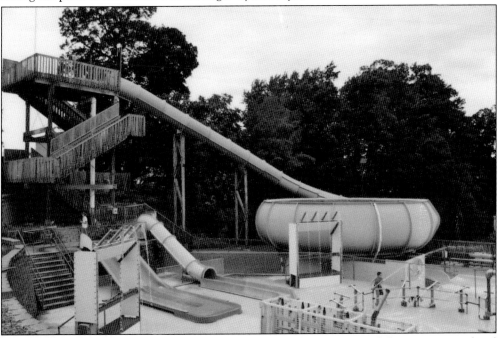

In 2006, Seabreeze focused on upgrading the waterpark. The Wipe Out! slides were removed and replaced by Helix from ProSlide Technology Inc. of Ottawa, Canada. Dropping off a tower about 45 feet high, riders in one- or two-person inner tubes drop into a giant bowl, where they spiral around until they slide out the "drain." In addition, the Banzai Speedslide was replaced with a new enclosed, and steeper, Banzai Pipeline slide. (JF.)

By 2008, the Gyrosphere was aging, and Seabreeze made the difficult decision to retire it. Its replacement was the Music Express, a flashy ride adorned with thousands of lights that offers guests a high-speed trip around an undulating track. The ride, manufactured by Bertazzon of Italy, was acquired from Wild West World, a short-lived theme park that operated for just two months in Wichita, Kansas. (SB.)

The north end changed again in 2010, when the Revolution 360° joined the lineup. Manufactured by Zamperla of Italy, the ride features a large spinning disk that travels back and forth along a U-shaped track. Seabreeze acquired the ride from Granite Park, a theme park project proposed for Fresno, California, that was never realized. (JF.)

Another longtime presence on the midway was replaced after the 2010 season when the Crazy Cups were removed. But guests could still spin themselves silly on the Twirlin' Tea Cups, which took the ride's place for the 2011 season. Manufactured by Zamperla, the new ride features six tea cups. (SB.)

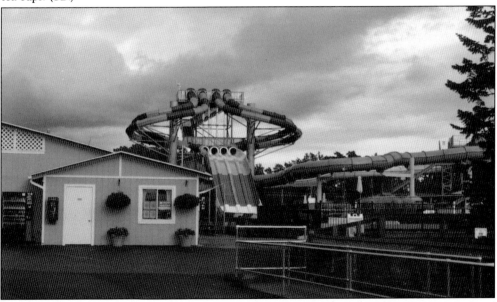

The retirements continued in 2012, when the waterpark's original waterslides were removed and the Hydro Racer took their place. Manufactured by ProSlide, the four 361-foot-long slides start atop a 53-foot-tall tower and send riders through a twisting tube slide before depositing them on a speed slide. The Hydro Racer was only part of a major revamp that included new walkways, queues, remodeled changing rooms, and a reconfigured Paradise Island. (JF.)

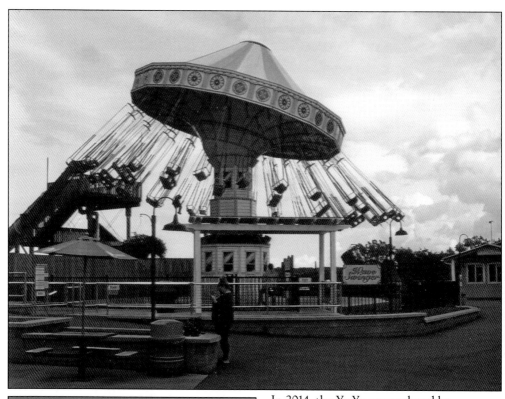

In 2014, the Yo-Yo was replaced by the Wave Swinger. Manufactured by Bertazzon of Italy, the Wave Swinger provided a similar sensation to the Yo-Yo. Seabreeze was able to acquire the ride from Freestyle Music Park in Myrtle Beach, South Carolina, after it closed. (JF.)

Also acquired from Freestyle Music Park was the Great Balloon Race. Manufactured by Zamperla, eight individual balloon cars take riders up 42 feet in the air, and guests are able to spin them freely as the whole ride rotates, providing a great view of the park. (SB.)

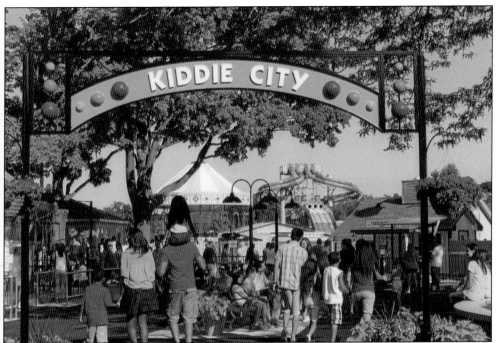

The Great Balloon Race was a fitting complement to the existing attractions in Seabreeze's kiddieland, as the whole family could enjoy the ride. It anchored an overall renovation of the kiddieland, named Kiddie City, to make it a more cohesive area. Rides were rearranged, some were given new themes, and the entire section received new, upgraded landscaping, benches, and lighting. Joining the Great Balloon Race were five rides that had been fixtures at Seabreeze for decades: T-Birds, Star Rockets (formerly the Sky Fighters), Flying Turtles, kiddie boats, and kiddie swings. (Above, SB; below, JF.)

The most recent ride added to Seabreeze was the Time Machine, which made its debut in 2017. Manufactured by Technical Park of Melara, Italy, the Time Machine swings 20 passengers up to 27 feet in the air, producing an intense side-to-side motion. (JF.)

While Seabreeze is an amusement park that is constantly updating and improving itself, it knows that what makes it special are its roots in the past. Throughout the park are parts of its 140-plus-year history that are still central to its identity. The old pavilion was converted into the Dreamland Inn restaurant in 1939; in 1957, it was relocated and turned into the park office. (JF.)

The former train station, which also dates to the park's earliest days, remains a fixture as the midway building, the central location for concessions including the gift shop, games, and the main refreshment stand. Its lengthy portico is an important part of the park's identity. (JF.)

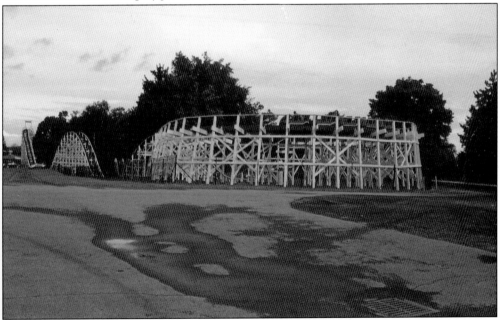

Of course, the Jack Rabbit, the park's most enduring attraction, remains the heart of Seabreeze. The oldest continuously operating roller coaster in North America, it still provides a thrilling ride even as it nears its 100th anniversary. It also represents one of the first applications of underfriction technology, which made roller coasters the thrillers they are today. The American Coaster Enthusiasts named it a roller coaster landmark in 2015. (JF.)

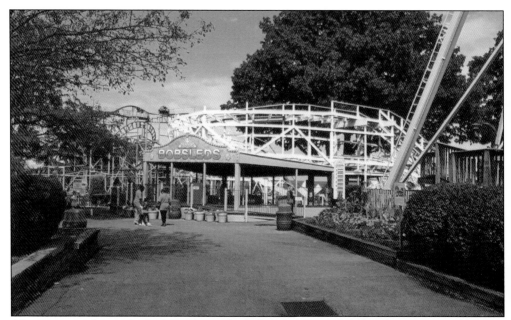

Almost as popular as the Jack Rabbit is the Bobsleds. The Bobsleds ride is a piece of history, representing the first use of tubular steel as a roller coaster track following the groundbreaking opening of Disneyland's Matterhorn Bobsleds. (JF.)

The key to the endurance of Seabreeze is the family that has been associated with the park for more than 110 years. Entering the industry in 1876 with the manufacture of their first carousel, the Long-Norris-Price family, seen here in 2011, represents the third oldest family legacy in the attractions industry. Their 70-year-plus ownership also represents the seventh longest ownership tenure of an American amusement park. Seabreeze is indeed in good hands. (SB.)

About NAPHA

Since 1984, Jim Futrell has served as historian for the National Amusement Park Historical Association (NAPHA), an international organization dedicated to the preservation and enjoyment of the amusement and theme park industry—past, present, and future.

NAPHA was founded in 1978 by a former employee of Chicago's legendary Riverview Amusement Park (closed in 1967) and has grown through the years to include amusement park enthusiasts from around the world.

Membership is open to anyone who enjoys amusement parks. Among the many benefits enjoyed by NAPHA members are *NAPHA Chronicle*, a magazine published four times a year, *NAPHA NewsFLASH!!!*, a monthly digital newsletter, conventions at amusement parks, and discounts at select amusement parks.

Throughout its existence, NAPHA has promoted the history of the industry by providing historical information to amusement parks, consultants, and architects, ranging from Time Out Entertainment Centers to Walt Disney Imagineering.

In addition, the International Association of Amusement Parks and Attractions (IAAPA) has often utilized NAPHA as an information resource. Over the years, NAPHA has also been contacted by countless authors, researchers, magazines, newspapers, students, museums, and even advertising agencies and has been credited in everything from books to the *New York Times* to Bruce Springsteen's *Tunnel of Love* record jacket.

The National Amusement Park Historical Association is the world's only organization dedicated to the enjoyment of all aspects of the amusement park. For additional information, visit NAPHA's website at www.napha.org.

Discover Thousands of Local History Books
Featuring Millions of Vintage Images

Arcadia Publishing, the leading local history publisher in the United States, is committed to making history accessible and meaningful through publishing books that celebrate and preserve the heritage of America's people and places.

Find more books like this at
www.arcadiapublishing.com

Search for your hometown history, your old stomping grounds, and even your favorite sports team.

Consistent with our mission to preserve history on a local level, this book was printed in South Carolina on American-made paper and manufactured entirely in the United States. Products carrying the accredited Forest Stewardship Council (FSC) label are printed on 100 percent FSC-certified paper.

MADE IN THE